How to Sell Your
HOLIDAY PICTURES

How to Sell Your HOLIDAY PICTURES

John Wade

 BFP BOOKS London

British Library Cataloguing in Publication Data:

A catalogue record for this book is available from the British Library

ISBN 0-907297-36-6

Front cover picture: PICTOR INTERNATIONAL – LONDON
All other pictures by the author

Published by BFP Books, Focus House, 497 Green Lanes, London N13 4BP.
Printed in Hong Kong.

ACKNOWLEDGEMENTS

Many thanks to a lot of people who have helped with the compilation of this book. First to Terry Scott, who helped considerably with the research. To Tony Boxall and David Tarn, who both agreed to be interviewed and to give away the secrets of their success. Thanks also to Carol Kipling, Mike Gerrard, Allister Macpherson, John Blay, Norman Rout, Dave Woods, Margaret Bickmore, George Gribben, Jeremy Burgess, Reginald Francis and Brenda Bickerton, each of whom supplied interesting case studies on how they have sold their holiday pictures.

John Wade

CONTENTS

INTRODUCTION

How much did you pay for your holiday last year? Whatever the cost, one thing's for sure – it was too much. Because make no mistake, if you are a half-way decent photographer there's no reason why you should pay for a holiday ever again.

No, that's not strictly true. Of course you have to *pay* for your holiday as far as handing over hard cash to a travel agent, hotel, airline or whatever is concerned. But the fact is, if you take the right kind of approach to your next holiday and go armed with the right kind of information, not to mention a camera, a couple of lenses and a bag of film, you should be able to make enough picture sales to cover the cost within a few months of your return. Market yourself and your pictures in the right way and, by the time six months have passed, you should be into profit.

What's more, those pictures should sell and sell, well after the date of your next holiday. When that time comes round, don't think you have to stop selling last year's efforts and start all over again. On the contrary, you'll now be in a position to add new pictures to your library, giving you even greater scope for profit.

Do I speak from experience? I certainly do, although it must be said that there is a little more to this business than initially meets the eye. How else could I be writing a whole book on the subject? Having read those opening paragraphs, you're probably now raring to jump on the nearest plane and make your fortune. Take this book with you, read it on the journey and by the time you get to your destination, you'll be a freelance machine, firing on all cylinders, ready and waiting for those money-making pictures to leap in front of your lens.

Well maybe. But, in all honesty, it doesn't work like that.

In fact, if you *are* reading this book on a plane, it's already too late for you to profit as much as you might have from this year's holiday. Sure, it will head you in the right sort of direction and it's a good bet that you'll take pictures on your trip that will be more saleable than they might have been without the benefit of this author's wisdom. But the real fact to take on board is that successful holiday photography, as far as the freelance market is concerned, doesn't start on day one of the holiday. It starts some

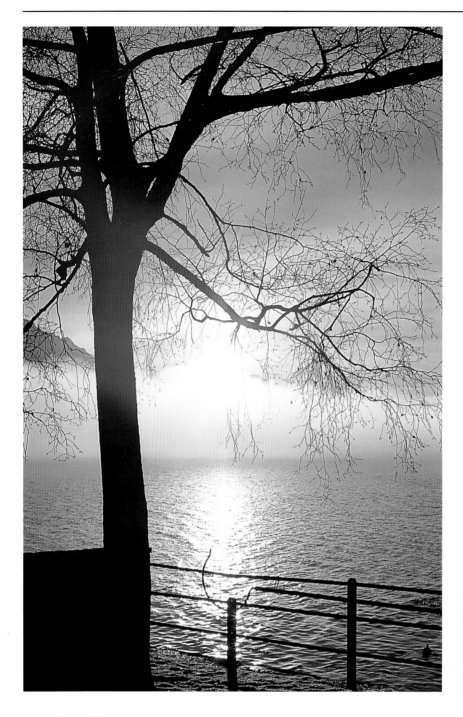

The traditional holiday sunset. It could find sales in travel articles, postcards, travel brochures, calendars and even greetings cards.

months before, as you plan what sort of holiday you are going to take, where, when, how and why. Because if you are going to succeed at this game, you should know the kind of pictures you are going to take and where you're likely to sell them, even before you leave.

That kind of thinking is nothing new to the established freelance, who knows the importance of investigating the market before taking the pictures. But if you are new to freelance photog-

raphy, that simple, yet all too fundamental fact, might come as a surprise.

There is, you see, a very big difference between the holiday snapshotter and the freelance photographer on holiday. The first takes pictures on a whim, to record events, people and places; the second takes pictures with a purpose. Pause for an example of what I mean, taken from personal experience.

Last year I went to the west coast of America, the year before, I went to Greece. *Amateur Photographer*, the British weekly photographic magazine, paid for both trips within three months of my return. Does that mean that I'm such a good photographer, the magazine was willing to publish my holiday snaps? No way. The fact is that before I left on each of those holidays, I had fixed up an arrangement with the editor of *AP* to write and illustrate a couple of supplements on basic photography – using the right filters, choosing the right lens, the basics of exposure, which film does what, etc, etc. So, before I left, I knew that I was going to need a lot of pictures, illustrating various basic photographic techniques.

Such pictures could have been taken almost anywhere, but to build the right kind of portfolio, using interesting subjects as a basis for the many different technical aspects of amateur photography, might otherwise have taken months, even for a full-time freelance. For a part-time freelance, holding down another job throughout most of the year, it could be all but impossible. So, what better opportunity than to take everything needed, using

Holiday scenery like this can help sell holidays in travel brochures.

various picturesque locations, while on holiday.

During two holidays, then, while my fellow travellers – and family – were busy snapping away at all the usual holiday subjects, I was taking a picture of the same scene through five different filters, or from different viewpoints with different lenses; while they were shooting colour prints that are easy to hand round when you get home, I was shooting colour slides, because most magazines prefer them to prints and – horror of horror – black and white film, because not every page of the planned supplements was going to be in colour.

Am I in a slightly privileged position, because I have contacts in the photo press? Of course. Would they buy my work if it didn't match up to their needs, even if they do know me personally? No way. Would they just as easily buy *your* pictures, if they were as right for their needs as mine are? Absolutely.

Those two supplements illustrate perfectly the right way of thinking in this business. They underline the importance of going on holiday in the right frame of mind, prepared to take pictures that are needed, rather than the sort you just take for their own sakes. I've spoken about just one specialist market for holiday pictures, but the principle of shooting the pictures that people want is universal, whatever the picture and whatever the market.

Am I going to tell you how to sell the pictures you took in Spain last year? I don't think so. Can I tell you the sort of pictures to take this year if you want to have a profitable holiday? Almost certainly.

Let's start by looking at who buys holiday pictures; it would almost be easier to say who doesn't!

The most obvious place, of course, is holiday brochures. Hundreds of different travel companies produce brochures each year, all full of pictures that are crying out to be taken in holiday resorts.

Then there are calendars and greetings cards, two very similar markets as far as requirements are concerned and each on the look-out for subjects that inevitably include the picturesque scenes that can be taken at holiday locations.

How about postcards? Every holiday resort is full of them, each showing views of the immediate area.

Posters? The taste in subjects needed by this market is always changing, but behind the different fads and fancies, there is always a need for the good, solid landscape/seascape/sunset type of approach that lends itself so readily to holiday photography.

Not forgetting magazines of course, perhaps the biggest market around. Here in the UK, there are literally thousands of different titles on hundreds of different subjects, the vast majority of which can be tackled on holidays.

And there are photo agencies, who service each of the above markets from their vast libraries of stock shots. Find the right agency and they could take just about anything you shoot on holiday.

Even skimming across the surface of the many markets open to the holiday photographer, you begin to see the many ways of making money with your holiday camera. But while fulfilling the needs of your chosen market is paramount, you also have to produce a quality picture. Many a potentially saleable shot has been spoilt by bad exposure, the wrong light, poor composition. So, having decided on your market, your next step is to refine your technique, so that not only the subject, but also the way you shoot it ensures success in the market place. That's something else we're looking at in this book.

Then there's the financial side. Did you realise, for instance, that once you start to make money from your holiday pictures, you can write a certain percentage of your holiday costs off against tax? You not only sell your pictures, but the taxman pays for part of the trip!

What about words? Start thinking about illustrated features, as well as straight picture sales and you double your potential overnight. The simple guidelines to interviewing, fact gathering and copy writing that you'll find in later chapters of this book will make that side of freelancing a lot easier than you might have expected.

To help you make the most of your holiday, you'll find this book organised in a definite order. In the early part, we look at the things you should do and think about before you leave. We move on to what to shoot while you are away and research that might need to be handled on the spot before your return. We give you some hints and tips on how to take better pictures in general. Finally, we look at how you need to organise yourself on your return.

But first and foremost, we have to look at our options, to examine the marketplace in advance to see what sort of pictures we'll be taking on this year's holiday, perhaps even allowing the market to dictate *where* we take that holiday. Which is why the first major part of this book starts, not with picture-taking techniques, but with markets...

TRAVEL BROCHURES

If ever there seemed to be an obvious place to sell your holiday pictures, the travel brochure market must be it. After all, what is a travel brochure if it isn't a glossy book full of pictures taken at holiday destinations? The trouble is, things aren't always what they seem. Yes, you can sell pictures of your holiday to travel brochures but, just as with every other branch of freelancing, you need to know exactly what's needed and how you can supply those needs.

Let's start, as always, by looking at our market. To the uninitiated, every travel brochure might look the same. To the freelance, trained in analysing a market, subtle differences immediately become apparent.

Types of brochure

We are looking here at brochures for overseas travel, rather than those that are produced for people who holiday at home, since this is where the biggest market lies. Here are three different types

Pictures which set the scene and show the attractions of an area to tourists are needed by travel brochures, but make sure you send identifiable locations like these only to tour operators who cover the places shown in the pictures.

of travel brochure to look out for and the kind of pictures you'll find in them.

1. The big, fat brochures that are put out by the larger holiday companies, full of package tours to well-known and frequently-visited resorts. These contain numerous pictures of hotels, from both the outside and inside. They might also contain pictures of people on holiday, but these will often be only incidental to showing us, say, a picture of the hotel's swimming pool or bar. They might occasionally use a picture of the resort's nearest beach or perhaps some local landmark that visitors might see on one of the optional trips offered by the package company, but basically it's the amenities available on the holiday that they illustrate, rather than the places themselves. The market for typical holiday pictures here is therefore limited.

2. The slightly slimmer brochures given away by those same big-name holiday companies, but this time aimed at more specialised travellers. These will be read by people who want to stay in villas, smaller family-run hotels, or even in what are sometimes called 'village rooms' – small units tacked on to the houses of local residents – rather than in the huge multi-storey complexes that less expensive package tours utilise. Holidaymakers of this type will be less likely to spend their whole time lying on a beach or round a pool. The type of person who takes this kind of holiday is more interested in the local scenery and, because the tour operator knows their market as well as you are supposed to know yours, those brochures will contain more pictures of local interest. A better bet for the holiday landscape photographer, then.

3. The specialised brochure that comes from the smaller travel company. These specialise in holidays for the more adventurous. They take tourists to places that the average package tour wouldn't touch: remote or faraway places like Iceland or India, interesting but less popular resorts like the west of France or the Italian Lakes, fly-drive holidays in places like America or Canada. These brochures sell the places rather than the amenities. As such, they provide an excellent market for the freelance photographer.

Types of picture

Now we know what type of brochure will give us the best chance of a sale, let's look at the kind of pictures that they use. These also fall into three categories.

1. Pictures of hotels and their amenities.
2. Pictures of foreign landscapes and places of interest.
3. Miscellaneous pictures, used as "fillers".

The first category doesn't have a great deal of potential for the casual freelance. The pictures come mostly from two sources: from the hotels themselves, who supply the tour operators with pictures free of charge, or from their own staff photographers – or photographers working under commission – who go out to the resorts for the express purpose of photographing the hotels in exactly the way the client requires.

But if this sounds as if pictures of this type are out of your reach, then think again. It is doubtful that such pictures would be bought in on spec, but it isn't out of the question for you to get yourself a commission to shoot for a tour operator in exchange for a free holiday and some travelling expenses. Naturally, you have to show that you are competent, and some published work in this or any relevant associated field will go a long way towards persuading a tour company that you have the right credentials. After all, they can't be expected to send an unproven photographer off on a free trip, only to find that he or she can't deliver the goods in exactly the way they are needed on return – by which time it might be too late to commission someone else.

On the other hand, if you can show competence in this field and win the trust of your prospective client, you might not earn a lot of money, but you will get a free holiday.

Our second category of picture is the best bet of the three for the average freelance. We all take pictures of the places we visit on holiday, and this is exactly the type of pictures to sell, given that you remember a few relevant points.

First of all, do remember that you are shooting pictures to attract tourists to certain places. You therefore have to make those places look as attractive as possible. Forget the photojournalist approach, showing ragged children in back-street slums. As regrettable as it might seem, the holidaymaker doesn't want to know about that kind of thing. Neither do they want to see busy city streets, full of crowds and traffic.

So take a positive approach. Compose your pictures carefully to show the most attractive aspects of the area in question. Take a genuinely pictorial approach and produce the kind of picture that will make people say: "That looks a nice place, I'd really like to go there."

In that respect, take careful note of the information on composition and quality elsewhere in this book. And don't forget that there really is very little point in shooting pictures of this type in anything but the best weather conditions. Prospective tourists aren't going to be attracted to an area that is shot under a dull grey sky. Blue skies and lots of sunshine are your watchwords.

With those first two categories, you obviously have to tie in your pictures with the tours being organised by your prospective

client. It's no use, for instance, taking pictures of a holiday location that you shot while on a holiday organised by one tour operator, and then submit them to another who doesn't cover the same area.

Our third picture category, however, doesn't have to follow these rules. What we're looking at here is filler pictures that are used in the brochures to give a little atmosphere. Children playing on beaches, pretty girls splashing about in the sea, good-looking couples enjoying a drink. All these pictures can be taken without any reference to the actual place where they were taken. In fact, the more anonymous they are the better. Purposely going for backgrounds such as sand, sea, or blue sky means they can be used in any part of a brochure without having to actually say the picture was taken at the resort being advertised on the same page. Get the sun right and you could take pictures in Bournemouth to sell holidays in Benidorm.

Look at the covers of most brochures and you'll see that these are precisely the kind of pictures that are used in this highly prestigious – and well paid – position. That's another reason why this third category of picture is particularly worth pursuing.

Taking such pictures, however, is not as straightforward as it might at first seem. Such pictures always include people and, although they might appear to have been taken casually or even candidly, it's a much better bet to assume they were posed. Look at the pictures that get published. Notice the way the people fill the frame, the way they have eye-contact with the camera, the way they are laughing together. Look too at the lighting. It's always perfect on their faces, and anyone who has tried taking people pictures in the harsh sunlight of a foreign climate will know that you often end up with shadows in all the wrong places, or people with squinting eyes. It all adds up to the fact that these pictures are posed, with a good deal of thought about matters like direction of light, reflectors and fill-in flash. (See the chapter on Basic Techniques for more information on how to take pictures of this type.)

As with everything else in this business, there are numerous sales to be made by the freelance who bothers to take that little extra amount of time and trouble to get the result the way the market wants it.

Who is buying?

Okay, so now you know what kind of pictures and subjects you are going to be shooting for the travel brochure market. But who buys them, how do they buy them and where do you find those buyers?

There are some areas of freelancing where you know that they

positively encourage the part-time freelance; others who you can say categorically deal only with professionals. But the travel brochure market is a law unto itself with no real hard and fast rules. A survey of twelve top travel companies revealed both good news and bad news for the freelance photographer.

Hotels come in all shapes and sizes, and tour operators are often interested in pictures of those covered by their company.

Four said they use their own photographer or specifically commission a professional and use pictures from no other source.

One said they commission some photographers, but also buy in from picture libraries.

Four said they buy in on spec as well as from libraries.

One said they buy only on spec, never dealing with libraries

Two said they buy only from libraries.

So the freelance photographer on holiday has a much better than average chance of making sales here, either by direct sale or through a library and, once you have made a few sales in this way, there is no reason why you shouldn't start looking for commissions. Don't be discouraged, by the way, by the fact that so many companies seem to prefer to buy in from picture libraries, because there is no reason at all why you shouldn't be the person who has supplied the library in the first place. The kind of pictures you take is what matters, and they should be the same whether you are selling privately or through a library. (See the later chapter on Picture Agencies for details of dealing with photo libraries.)

What were the surveyed travel companies looking for? Naturally, the kind of picture we have already discussed: those with plenty of holiday atmosphere, beaches, local sights, pictures that show the flavour of the area.

Only colour transparency film is acceptable in this market and medium or larger formats are preferred. But don't let this put you off. Providing your pictures are sharp, well exposed and with a good saturation of colour, just about every travel company accepts 35mm today. What they do not accept are colour prints.

Holidays are no longer taken exclusively in the summer

months, so brochures are produced all year round, usually for a summer and a winter season. Most companies buy their pictures, however, around May and June.

If you aim to sell your holiday pictures to this market through an agency your first step is to find one that deals with this kind of subject, and you'll find more details on that in the chapter on picture agencies. Alternatively, if you are going it alone, you'll need an address to which you send your pictures or where you can

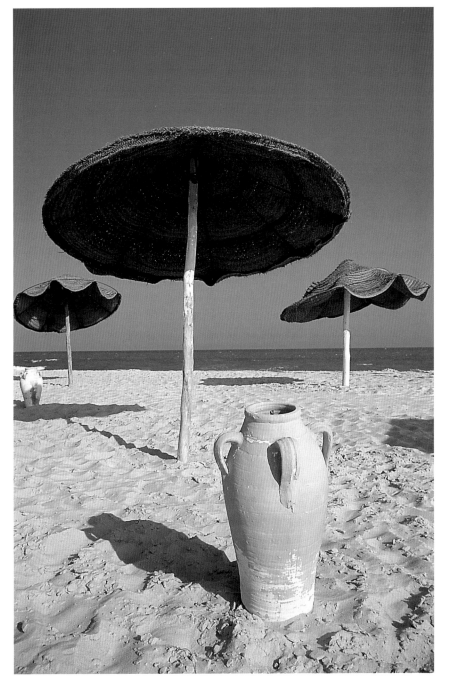

A picture like this could have been taken almost anywhere, so you don't have to worry so much about matching the location to the tour operator. They can be used as filler pictures in brochures.

make initial inquiries about their requirements.

We could list current agencies and contacts here, but the life of a book being what it is means that the information could easily be out of date by the time you read these words. It is a simple matter, however, to track down addresses for yourself. Most travel companies have an address listed in their brochures. Failing that, the larger organisations will have London offices that can be traced through BT's directory enquiries service.

The titles of the people who are waiting to hear from you vary from company to company. In some you might be dealing with a customer services manager; in others you'll be talking to a sales or marketing person; some might even employ the services of a separate agency to handle their brochures. In any case, a simple telephone call, explaining to the person on the switchboard that you need a contact for the person who buys pictures for their brochures, will soon set you on the right road. If you are fortunate, you will be able to speak to the person there and then, but if you lack that confidence, or if the person concerned doesn't take unsolicited phone calls, you can go away and write a letter, explaining who you are, what you have to offer and asking for their requirements.

Tips from the top

Nowhere will you get better advice on this subject than from photographers who have already had some success in this market. So let's now take a look at the experiences of someone who has been selling regularly to travel brochures for thirty years.

Tony Boxall is an amateur photographer by definition, simply because photography is not his full time job. But the success he has had in the field of travel brochure photography would put many professionals to shame. He sells all his pictures through a couple of different picture libraries, and has been making steady profits for over 30 years.

His pictures are not taken at exotic locations unavailable to the average photographer, but on straightforward package tours. So how does he go about taking a successful travel brochure picture?

"Although I know many markets today are willing to accept 35mm, I have always shot on medium format with a slow ISO 50 film speed," he says. "That doesn't mean I use expensive equipment, though. I have been using the same Mamiya twin lens reflexes for years. There is a good reason for that. When a client visits a library, he has an enormous choice of pictures to consider. Let's say that a library has 5,000 pictures in stock, including ten pictures of Malta, mostly 35mm, but a couple in medium format. It's the medium format shots that the client is going to look at

first."

Although he has a complete set of interchangeable lenses for his cameras (Mamiya make the only twin lens reflexes with interchangeable lenses), Tony finds the 80mm standard the most useful for this kind of work.

The sort of pictures he takes on holiday are not the sort of shots that the average photographer takes. That's because he is thinking about his market as he shoots – something that is essential if you want to succeed. Ordinary holiday pictures won't sell, but his kind of holiday picture does. So what's the difference? Tony explains further...

"I take the kind of pictures that capture the atmosphere of the area or the country I am in. I look for nice blue skies, beaches and hotels. In that respect, I don't shoot the hotel the way the brochure's professional photographer does, but in a way that puts it into context with its surroundings.

"Atmosphere is the word that is always uppermost in my mind. For example, let's say we are in the Greek islands. Each island has its own personality. Some might have beautiful windmills, others are noted for specific wildlife like pelicans. That sort of thing identifies the island, and that's what the picture buyers look for when they visit a library.

"Or I might shoot something as simple as a couple of Greek urns, a bottle of wine on a table next to a salad, or a man riding a donkey down a hillside. Subjects of that type spell out Greece in general. They could be taken in one area, but used to sell a holiday in another.

"Whenever I book a holiday, I raid the travel agencies and get hold of all the brochures that cover the area I'm going to. I cut out the pictures and take them with me as a reminder. You shouldn't be afraid to re-take a subject that has been used before. Take it from a different angle, give it a slightly different treatment and there's a good chance of success. By and large I find if something has sold once, it will sell again.

"When I am away, I go on all the optional trips that are available because they show me areas of interest that I might not otherwise have found for myself. Invariably, when I am on an organised trip, the light is all wrong for decent photography, but that doesn't matter. I make notes of places I want to shoot, where the sun is at what time and, later, I hire a car for a couple of days and revisit them at the right time for the best photography.

"I always talk to and involve the locals whenever possible, because something like a beekeeper, working with his hives, for example, makes a much better shot than just the beehives on their own."

Although many agencies – and some travel brochures – have

started to use creative pictures, shot with the use of special effect filters, it is Tony's experience that the picture that stands the best chance of a sale is the one that has been shot "straight". He rarely uses filters or super-wide or extra-long lenses, even on the rare occasions that he uses 35mm. He is, he says, never tempted to fake a picture, such as using a filter to make an ordinary scene look like a sunset. "Inevitably, it leads to problems when the holidaymakers complain to the agents that the place has not been properly represented in the brochure, and you can guess what that does to your future chances of sales."

Tony finds that it isn't just the pictures he is taking now that sell. Over the years he has built up a stock of around 40,000 pictures at two agencies and shots that he took ten years ago are still selling today. And, he reckons, there is still a market for even the most well-known landmarks like the Eiffel Tower in Paris or the Tower of London.

The only trouble is that when Tony comes home from his holiday, sorts his pictures and sends them off to the agency, he gets complaints from his wife because, unlike other couples, they have no holiday pictures to show their friends!

The home front

Throughout this chapter, we have been dealing with travel brochures for overseas destinations. That's where the big market is, but don't overlook the home front. Everything that has been said about the type of foreign-based pictures that sell applies equally to taking pictures for UK holiday brochures. The big difference is that there aren't as many brochures about.

The very fact that you have booked your foreign holiday with a tour operator is enough to assume that there are brochures needing your pictures. But British holidays are more likely to be taken under your own steam, so don't automatically think that there is going to be a brochure ready and waiting for every picture you take in the UK.

Happy families in anonymous settings make suitable submissions for travel brochures.

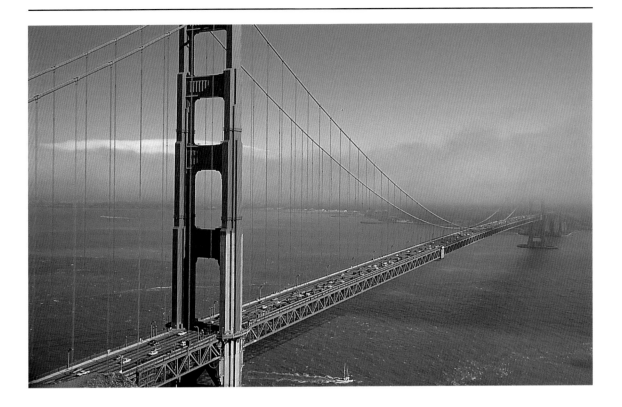

So check out your local travel agents. As well as foreign holiday brochures, they will also have, to a lesser extent, information on UK tours. Take some brochures and look at the areas they cover, so that when you are away you are shooting only for the markets that you know actually exist.

Don't expect there to be a market ready and waiting for every holiday destination in the British Isles. There is a market here, but the vast majority of your holiday brochure sales will come from pictures taken abroad.

A shot of Golden Gate bridge that could well appeal to a tour operator selling holidays in America.

POSTCARDS

What holiday location isn't full of racks of postcards, showing the area from every conceivable angle, just waiting to be plucked off the shelves by tourists to scribble on and post home. They sell by the million, so the market is vast.

There are two different types of postcard. The first is the traditional type, showing views of holiday resorts and their associated areas; the second is the more artistic approach, comprising subjects like animals, romantic couples, children, etc. That's more the type of card that is sold in poster and art shops.

The traditional card

The obvious area for the holiday photographer to concentrate on is the first type, and the subjects that are needed can be found on almost any holiday.

We're looking here at traditional holiday scenes: beaches, clifftops, panoramic views of the countryside. Then there are the more specialised subjects, like stately homes, gardens, zoos, all of which sell postcards of their own establishments. Or how about floral subjects? You might go for close-ups of particular blooms, but you'll probably make better sales in this market from more general pictures of well-tended displays of plants and flowers.

If you're selling cards to tourists, they really want to show the folks back home the places they have visited. So a specific place sells better than the kind of sunset across the sea approach that could have been taken anywhere on almost any coast.

Animals are another favourite topic, as are children in the right circumstances. The thing to watch out for here is to keep fashion out of the picture – something we'll be dealing in more detail in a moment. The styles of children's clothing change year by year, dating a card all too quickly.

Working out what kind of subjects sell to postcard companies is only really a matter of common sense, since we've all seen and bought picture postcards on our travels and we should therefore all have a pretty good idea of the subjects to look for before we leave. There are, however, a few general points worth remember-

ing about this market and if you have them firmly fixed in your mind before you leave, you'll stand more chance of selling when you return.

First, this is a market for colour. There was a time when postcards were taken, printed and sold in black and white, and even sepia tones. But, as far as the traditional holiday seaside type of card is concerned, those days are past.

Because the end product here is quite small, this is an area in which you won't have too much trouble selling 35mm. Medium format is always an advantage of course, and the postcard market is no exception to that particular rule. But, in general, providing your quality is tip-top, the image is sharp and the colour is well saturated, you should have no problem selling 35mm slides.

There is, of course, the weather to consider. If you're shooting abroad, hopefully that won't cause you too much trouble, since most foreign holiday destinations are chosen for their sunshine. Shooting in the UK, however, could present problems because of the uncertainty of our climate.

But take a look at the postcards you see on sale, even in the UK, and you'll notice that they all have one thing in common: they are taken in good bright sunlight with plenty of blue skies. If you want to sell yours, then, you must make sure your pictures are taken in similar conditions.

So don't shoot when the day is dull or overcast. The chemistry of modern colour negative films might give you bright colours on dull days, but the colour slide film you should be using for freelance purposes will be far more faithful to the original conditions – and dull weather produces dull pictures. Not the sort of thing that sells postcards.

Try to shoot pictures that are timeless. Again, take a look at the cards in the shops. You'll see that the views rarely show people in fashions that might date, or include cars that will likewise look old fashioned in a few years time. The reason is simple. Once a postcard publisher has bought a picture from you, he will want to use it for as long as possible. Fill the picture with fashions and styles that will be out of date in a few years time and you'll reduce your chances of a sale.

Finally, think about your approach to the subject. Most of the big sellers are straightforward views. So don't try to be too clever. Stick with what you see in the shops.

On the other hand, there's no harm in risking a little imagination here and there. Many of the views have been taken in the same old traditional way for years, dating back to the days long before the use of special effect filters, for instance. So yes, go for the traditional approach, but also introduce a few effects on the right kind of subject. A graduated filter, a starburst, a diffractor...

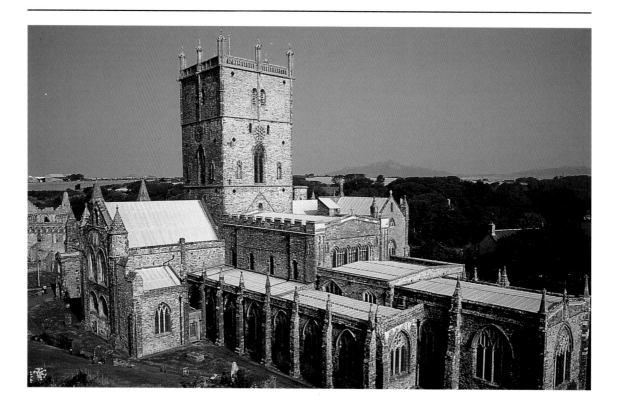

they'll all give your pictures a slightly different look that might help them sell to certain publishers. Not all, though. So put the special effect pictures side by side with traditional approaches and let the picture buyer decide which approach he or she prefers.

Well-known local landmarks are always in demand by post-card publishers.

The art card

Recently, there has been a new development in postcards, printing the kind of subjects that, previously, have been reserved more for the poster market. In fact, in many cases, the postcards are merely smaller versions of subjects also on sale as posters.

These comprise pictures which are not typical holiday subjects, although many of them are the kind of subjects that you might spot on holiday. Take a look at the range in your local poster shop before you leave and you'll find subjects like children in humorous situations, animals; often also with a touch of humour, romantic couples, classic cars, motorbikes...

At the time of writing, the current trend is for these pictures to be produced as top quality black and white illustrations, occasionally with hand coloured areas.

This isn't a market to dwell on too much in a book of this type because, as we've already discussed, they are not typical holiday subjects. But, before you leave for your holiday, it will do no harm at all to take a walk around a good poster shop, absorbing the

kind of subject matter that is being used on these postcards and the way it is presented, because you never know when an opportunity for similar pictures might present itself while you're away. And you'll always stand the best chance of success if you know what you're looking for in a picture before you reach your holiday destination.

Publish your own

There is another way of handling the postcard market. Instead of selling your pictures to a known publisher, who will pay you a set fee whether he sells five or five hundred cards, you could think about publishing them yourself. That way, the more you sell, the more money you make.

This is one of the very few areas, in fact, where the freelance photographer has the potential to turn publisher. After all, it would be a foolhardy person indeed who tried to publish a magazine or a book without any previous experience. But postcards are a little different and, if you have a bit of capital that you are prepared to risk, then it's a worthwhile operation.

So where do you start? Just like any other branch of freelancing, you start at the end – with the market. The trained freelance, aiming at magazines, would never take pictures without having some kind of idea about which publication he or she is going to approach, and it's no different for the prospective postcard

An artistic approach, rather than the straight record shot of a place, appeals to some postcard companies.

publisher.

Your market in this case, however, is a little different from the printed media. Unlike magazines, travel brochures and the like, this is a market you can contact face to face. We're talking about the shops in which the cards are sold. But before you get on holiday and start chatting up the local souvenir shops, there are few preparations that you must make.

The first two questions you're going to be asked when you approach prospective customers are how good are your pictures and how much will the postcards cost. So go on holiday with the answers ready at your fingertips.

Once you have produced your first set of postcards, you can use those as samples to sell your next set. But when you are starting from scratch, you're going to have to fake it. Do that by visiting your nearest photo lab and getting, say, half a dozen good quality colour prints made. Have them hand printed and specify that you want them, not the traditional size of photographic printing paper, but the size of a postcard. That's about 150 x 105 mm.

If you already have some typical postcard type subjects from previous holidays, all well and good. If you haven't, it might be worth a day trip to your nearest coastal resort to take some pictures specifically for the task.

Whether you select pictures from your files or go out to take them specifically, remember the points already discussed above about the type of pictures that sell to this market. But also remember that many of the traditional postcard pictures are a little corny. Give yours something a little different, perhaps with a few of those special effect filters – subtly used, not overdone – and you could find you've upped your sales potential.

Half-a-dozen different prints of this type should be enough to whet the appetite of your prospective buyer. Now get prepared for the next question: how much are they going to cost.

The answer to that is reliant to a large extent on how much they are going to cost you to print. And by "print", we're not talking about photographic printing. It's time to visit a real printer to cost the job.

Every town has a number of printers and you really only have to look in the Yellow Pages to find a few nearby. Don't be content with one. Get three or four different quotes before you start, ask to see samples of the printer's colour work and then go for the best and most cost effective.

Printing is a funny business – and printers are funny people. You'll get far more respect, and a better price from many of them, if you go in giving the impression that you know what you are talking about. Which isn't always as easy as it might at first seem. The printing trade is rife with terminology that could leave you

confused. Understanding it and talking to the printer on his own terms will definitely help.

So let's see if we can dissolve some of the mystery of the printer's jargon that you might come across. Here are some questions you're likely to get and how to make your reply.

What are you supplying?

You are supplying colour slides. Even if you used colour negative film to make colour prints for those samples of your work, you should now be using slide film for the originals that you want printed. But don't talk about slides, talk about transparencies or trannies.

How many colours do you want them printed in?

The obvious answer is all of them, but that won't wash with a printer. To him, "colour" can mean a job printed in black with just one extra colour on it, in which case it's a two colour job. The correct expression for what you think of as full colour is "four colour". This is because any colour picture is printed from four basic process colours – magenta, cyan, yellow and black. So tell the printer you are looking for a quote for a four colour job.

How many scans do you require?

Each picture that you want reproduced in colour is scanned on a machine that separates its colours into those four process colours. So each of your postcard subjects represents one scan.

Are they in pro?

This means can they all be sized at the same ratio to produce the same sized final image? Or are you going to want the slides cropped in different ways on different cards? If you've handled your picture composition right in the first place and assuming all your postcards are going to be the same size, then you should be able to have everything made "in pro" – which stands for "in proportion". Working that way, so that several or all of the trannies can be scanned together, rather than having them reproduced to different sizes from different areas of the original, will reduce the bill.

How many to view?

This means how many different cards are you going to have printed at the same time? It's a good idea to work this out in advance and in the most economical way. The printer, you see, won't want to print each individual postcard separately. He'll want to print them perhaps four-up or eight-up. That means, four or eight to a sheet, which will then be sliced up (or "trimmed" in printing parlance) into individual cards. The number of cards to a sheet should be a multiple of four for maximum cost effectiveness.

Most printers will have printing machines (which you should always refer to as "presses") that take A3 paper. Some will take A2 or even A1. But, for starters, work to the A3 size. That's

295x420mm (don't talk inches to printers these days), so you can get eight different cards, 147.5x105mm, out of a single sheet of A3.

Any bleeds?

That means does the picture go all the way to the edge of the card, or are you going to leave a small white border around it? Most traditional postcards are bled to the edge. But it's cheaper – and perhaps a little more classy – to have a white border. Be prepared to give your answer on how you want yours presented.

What's the stock?

This refers to the paper or card on which you are printing. The printer talks about this in terms of gsm. That's grams per square metre, the actual weight of the paper. For a postcard, you want something like 240 gsm white card.

Do you want it laminated?

That gives a varnished coating to the picture. It's a good idea to have a postcard laminated on the picture side.

What about the reverse?

Now we're talking about the other side of the card, on which the address and the message is written. This only needs to be printed in one colour, and in theory it can be any colour you like. But for safety's sake, stick to black. Also, have a rough design ready to show the printer what you want. You can copy that from any traditional postcard. Nothing more than a line (which a printer calls a "rule") down the centre, to divide the address from the message, perhaps a drawn square (a box) for the stamp and a

Picturesque villages can be sold to established companies, or might be used as a basis for printing a set of cards of your own.

byline for yourself.

What size type?

The printer will set the type and prepare the artwork for this if necessary, but he'll want to know what size of type you'd like on the words. Type sizes are designated in points. To give you a size that is readable without being too big and overpowering the space available for the message, go for eight or nine point.

What face?

We're now talking about the actual style of the letters. By all means ask to see some samples of typefaces if you want to, but otherwise stick to something that is perfectly safe. When in doubt, go for a typeface called Helvetica. It's simple, straightforward, easy to read – and every printer has it.

What's the run?

The "run" is the number of postcards you want the printer to produce. But remember that if you are printing them eight-up, each sheet of the run refers to eight different cards. So ask for a 1,000 run and you'll get 8,000 cards of eight different views.

This last question is perhaps the most important as far as you are concerned, because this will dictate the cost of the card to you. In any form of printing, the biggest amount of work for which you are being charged comes from scanning the pictures, planning the job, turning it into plates for the press and getting the machine ready to run the job. Once that initial work has been done, the extra cost is reliant only on the paper, or card, on which the job is

Hotels often need postcards for sale to guests, so if yours has a feature like this, photograph it and ask the manager if he is interested in buying it for his own uses.

being printed and the machine time. So, a run of 2,000 is not going to cost exactly twice a run of 1,000. It will, in fact, cost a lot less than that.

From this, then, you'll see that the more you print, the less the cost of the individual card. What you have to do is work out how many cards you can afford to print in the expectation of selling.

Having said that, remember that at this stage you are only getting a quote so that you can work out the cost of the cards and so tell your prospective customers how much they will cost. The best idea is to get the cost for printing, say, 1,000 and then ask for a 1,000 "run-on". This will tell you how much extra you'll have to pay over and above the cost of the first 1,000, and you can use the figures to work out how many postcards you want to produce.

From there, it's a simple matter of working out what is called the unit cost. This is the actual cost of each individual card, found by simply dividing the number of cards you have produced into the printer's price. Say, for example, you have printed 1,000 sheets eight-up. The unit cost, therefore, is the printer's price for a 1,000 run (8,000 cards), divided by 8,000.

From there, you can work out how much profit you wish to make for yourself over and above the printing cost, bearing in mind how much profit the shop to whom you are selling will also want to make. If you can afford to sell them the cards for about two-thirds the retail price, they should be fairly happy. Sell them your cards at half their selling price and they'll be even happier.

So, having got your samples together and your prices worked out, it's time to leave for your holiday and hit the holiday resort high streets. We'll talk about how you do that in the chapter on Holiday Research.

CALENDARS AND CARDS

Although calendars and greetings cards are two different markets, they have so much in common that it's a good idea to look at them together. Subjects which sell to one can very often be sold to the other and each has similar technical demands.

There is currently a growing interest in black and white pictures for greetings cards, although subject matter here isn't the kind of thing you normally associate with holiday photography. We're talking about animals, children, off-beat pictures of different subjects. Take a look in your nearest poster shop and you'll see exactly the kind of thing being used at the moment, and if you come across this kind of subject on holiday, then there is a ready market awaiting your pictures.

When we think of more traditional greetings cards and calendars in association with holiday photography, however, we are far more likely to be thinking in terms of landscapes for both markets. To this we can add floral subjects, as part of a landscape for both markets, or in close-up for greetings cards rather than calendars; and pretty girls, more for calendars than greetings cards.

Quality counts

Apart from those specialised greetings cards mentioned at the start of this chapter, these markets demand colour. And with only a few very rare exceptions that means transparencies rather than prints, the bigger the better. There are markets in both these fields that will consider 35mm slides and even colour prints, but they are the exception rather than the rule. And, given the choice between a 35mm and a medium format transparency, they will go for the larger format every time.

So if you want to make a killing in this market, you should think seriously about investing in a medium format camera, even if it's only a secondhand twin lens reflex. These are markets in which you need to take the most amount of care with your technique. Quality is paramount, and that doesn't just mean getting exposure right. Accurate focusing technique is imperative as well.

This is especially true if you are photographing floral subjects –

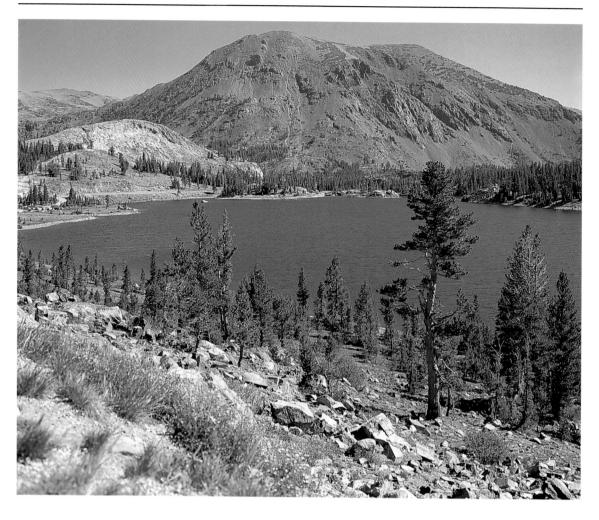

a firm favourite with greetings card publishers. It's all too easy to move in for a close-up, focus on part of a bloom that is closest to you, only to find that petals only a few inches behind have fallen out of focus – something which can easily detract from your chances of a sale.

Good quality scenic subjects work in both the calendar and the greetings card market.

The same can be said of landscapes that you might shoot for the calendar market. If that gate that you carefully positioned in the foreground as an aid to composition is slightly blurred because you are focusing on infinity for the landscape behind, then you have once again damaged your chances of a sale.

In both of these markets, then, depth of field is an important factor. If that's a technique you're not sure about, then check out the details in the chapter on Basic Techniques.

Know your market

Greetings card and calendar companies get their pictures from two sources: picture libraries and individual photographers. The

Cathedrals and churches make good subjects for certain calendar companies.

good news is that these are not markets that work exclusively with libraries to the exclusion of all else. The vast majority of the publishers surveyed for this book reported that they were always interested in hearing direct from freelances. However, whichever route you take, be it direct to the publisher or via an agency, the demands on the way you work are exactly the same.

It's an easy mistake for even the most experienced freelance to make incorrect assumptions about calendar and greetings card markets. The photographer who sells work to a magazine would never dream of submitting pictures of pets to magazines that deal only in gardening, or vice versa. But with calendars and greetings cards, there seems at first to be no limits. They all just use pretty pictures of almost any subject. Right? Wrong! Many of the companies that produce calendars and greetings cards deal in specialist subjects. One that takes pretty girls won't necessarily be interested in landscapes; the one that takes landscapes won't always want

animals; the one that buys animal pictures won't necessarily be interested in floral subjects. And so it goes on. It is, in fact, just like the magazine market. Rather than merely taking pictures and then sending them off to any calendar or card publisher that catches your eye, you should choose your market first, then take your pictures to suit the needs of that market.

So how do you find out who is buying what? One very good way is to simply look at the lists in *The Freelance Photographer's Market Handbook*. That's an annual directory of markets for the freelance, published by BFP Books from the same address as the book you are now reading. Each year, its lists include the current requirements of major calendar and greetings card publishers.

Another way is to simply get out there into the shops and do your own market research. Over the past few years specialist shops, selling primarily greetings cards and calendars, have sprung up in most major towns. Get in there and really look at what sort of pictures are being used. Buy a few cards and calendars and study them the way you would study a magazine that you wanted to sell to. Most card and calendar companies have their names printed on the product somewhere, often with an address to which you can send your pictures.

A word of warning, however, in the greetings card sector. Don't confuse photographs with artwork. At one time, greetings card companies used a lot of photography. Today, they are biased towards clever artwork from artists rather than photographers. A company that appears to be using nothing but artwork won't be interested in your pictures, so concentrate only on those cards that have obvious photographs on them.

Approaching the subject

By now, you know what kind of subject you are going to shoot and where you will be sending your pictures on return from your holiday. The next thing to think about is your approach. Do remember that a calendar picture is designed to be hung on a wall for a month or more; a greetings card picture is designed to zap someone between the eyes when they open an envelope, to say something special from one person to another. Both philosophies mean the same thing to you as a photographer: they mean that if you want to sell your pictures, you need to come up with something different in your approach.

Take greetings cards. Flowers are perhaps the biggest seller to this market, so it's all too easy to think you can simply pop into one of those public gardens that you so often see in holiday areas, photograph a few roses in close-up and make a sale. Not so. Take a look at the roses on the cards in your nearest card shop and see

how the photographers have taken different approaches. It might simply be the way the rose has been laid on a different kind of background; it might be lighting; it could be the way the flower has been used with other accessories, roses and jewellery, for example. But one thing is for certain: the picture that has made a sale to the greetings card company will rarely be of a flower alone, taken in a public garden or on a hotel patio on your holidays. Floral arrangements, despite what might at first seem obvious, are often more for the studio photographer than for the holiday photographer.

Take calendars. Traditional landscapes, such as you are bound to come across on holiday, are needed here. But again, think about the slightly different approach which will turn an ordinary landscape into the kind of picture that you would actually want to look at for a month or so on your kitchen or office wall. Would the subject look better if it was framed by a doorway, an arch or perhaps the branches of a nearby tree? Is it worth adding a subtle special effect in the form of a graduated filter? Would it be better to return at a different time of day, when the sun is lower in the sky and the light is more golden? Little things like these make all the difference between sale and rejection in the markets we're considering here.

The shape of the picture is equally important. Most greetings cards, for example, are deeper than they are wide. Some calendars use deep pictures too, while others use wider formats and some might even use square pictures. Whatever your chosen market wants, that's what you must give them. There is, in fact, very little point in shooting conventional horizontal pictures for the greetings card market. Much better to turn your camera on its side and take a vertical shot to fit the format of the average card, rather than what might be the more obvious shape of the subject. Or, if you are using a square 6x6cm format, compose your picture so that it can be cropped at the sides without losing its effect.

Look also for themes. Some calendar companies like to cover the whole country in one calendar; others prefer to concentrate only on certain areas. They might, for example, publish a calendar that uses nothing but Scottish scenes.

Some of these calendars could be made up from pictures taken by twelve different photographers. It's easier, however, for the company to use twelve pictures from one photographer, providing all the pictures are on the same theme and in the same shape format. The fact that the photographer has his or her own style will give the final calendar a better unity.

So if you happen to be going to a particularly scenic part of the country or the world, try to take a set of pictures that work together as a theme. After all, twelve sales are a lot better than one!

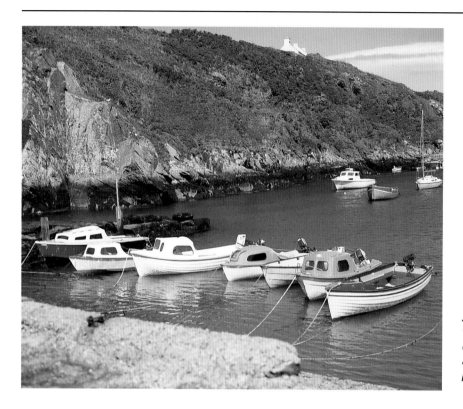

A picture of this type would appeal to a calendar publisher as well as a greetings card publisher aiming at the "male" market.

It's also a good idea to look at exactly how your intended publishers use pictures on their cards. Some bleed the picture to all four edges, meaning that space should be left in the composition for the inclusion of greetings text at the top. This can actually be quite useful because it tends to square off a composition that doesn't lend itself naturally to the vertical format: you simply compose the picture in the lower half of the frame, leaving "too much" sky area at the top for the greetings.

Other publishers prefer to drop their pictures into a frame on the front of the card, the way some magazine covers do. In that case, you need to compose more carefully to the exact shape of the photographic image.

As always, these differences should be investigated, noted and adhered to, depending on the company to whom you are aiming to sell.

Think too about when you are going to submit your work. Some calendar and greetings card companies are prepared to look at pictures all year round, but many more have certain times of the year for buying, often in the autumn and early spring. The busy Christmas period should be avoided completely as far as the greetings card market is concerned. Once you have sorted out to whom you are sending your pictures, a polite phone call will tell you the best time of year to make your approach.

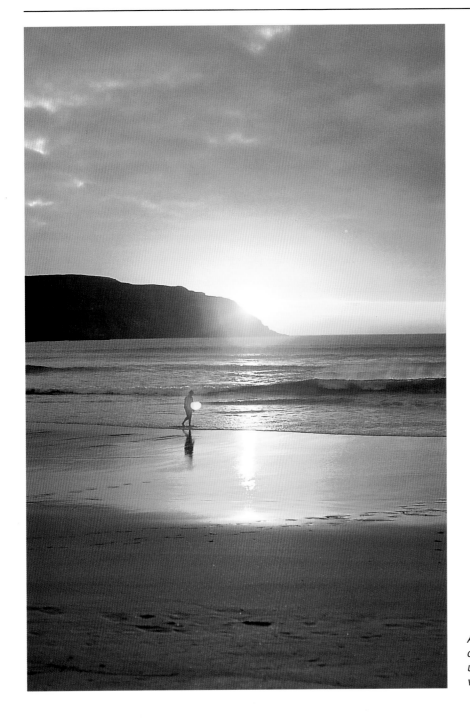

A good greetings card picture, especially useful because of its vertical format.

Expert's Advice: Greetings cards

Now let's turn to the actual clients, to hear what they have to say about their needs, as they apply to the kind of pictures that you are likely top find on holiday. This advice comes from the art manager of a company called Hambledon Studios, whose speciality is the greetings card market.

For their particular market, the company stresses that 35mm is definitely a no go area; the case with many greetings card companies, as opposed to calendar companies. Ideally, they like to work from 5x4 inch or even 10x8 inch original transparencies, but are happy to consider good quality medium format work as well. Exposure, they emphasise, must be accurate as good colour saturation is essential. Underexposed or sombre pictures simply do not sell. Image sharpness is important all the way through the scene, corroborating what we have already said about depth of field. Skies should be bright blue (don't forget your polarising filter), preferably with a small white cloud or two.

Their biggest and most competitive market is for flowers and they repeat the advice already given about trying to make the subjects different by use of backgrounds, lighting and props – not the easiest of things to do on holiday. A better bet, then, is look at their advice on landscapes.

Landscapes are mostly used in the male greetings card area and so should obviously be taken with this in mind. That means pictures stand the best chance of success if they include male-oriented interests such as vintage cars, fishing, horses, boats, etc. General rustic views are also acceptable. For the smaller female market, cottages and flowers are more suitable. All pictures should be taken in a vertical format, which can be quite a challenge to the composition of a picture.

Animal studies are also strongly considered, and here again, think about your market. Dogs such as Alsatians, Great Danes and boxers fit into the male category of greetings card; poodles, puppies or almost any smaller, appealing dog or cat is better for the female market.

Expert's Advice: Calendars

For advice from an expert on the calendar side of this market, we turn to a company called Calendar Concepts and Design. They consider portfolios of top-quality work for corporate calendars, produced for a range of business clients. This in itself shows how different calendar companies have different specialities, and how important it is to match your way of working to the needs of a potential client, rather than simply shooting at random. Calendar Concepts and Design buy a range of subjects that could easily be found on holiday: landscapes, nature, transport, glamour, etc.

The company asks initially for between twenty and thirty images based on a particular theme. They will then use these as the basis for making a presentation to one of their clients. Because the pictures you submit might well end up on the same calendar, you should present them all in the same format – i.e. all horizontal

or all vertical, not a mixture of both. They take only transparencies, not prints, and would like to see them in the largest format possible.

Excellent photography and creative composition undoubtedly helps to make sales. The transparencies, however, need not be presented in those large black card mounts that can often look so impressive. At the end of the day, the picture stands or falls by its content.

If your pictures are chosen for a calendar, then you will be offered a fee to cover the calendar rights for one year.

Landscapes, they say, are undoubtedly their best sellers, which must be good news for the photographer who is out to profit from holiday pictures.

Expert's Advice: The photographer

To get expert advice from a photographer, we turn now to David Tarn, who not only shoots for calendars, but who also produces one of his own as self promotion for his photography. Most of his work is in landscapes around the north of England and Scotland.

David sells a lot of his pictures through a Scottish picture library called Scotland In Focus, and all the pictures of his they currently hold were taken during holidays in Scotland. He found the agency simply because one calendar company to whom he had been selling regularly suddenly told him they were now buying their material from this agency. It was time, David felt, to lodge his pictures with the agency and they have sold regularly on his behalf ever since.

Over the years that he has been aiming at calendars, he has gradually adjusted his way of working to fit in with the needs of the market.

Although David uses the Scottish agency (which also sells his holiday pictures to holiday brochures and book publishers), he sells most of his calendar work direct to around half a dozen different companies. He sells both 6x7cm and 35mm transparencies, although he stresses that only one company readily takes 35mm. The rest want the larger formats. This was particularly pertinent on one calendar shoot that unusually wanted all vertical pictures – they cropped them from David's horizontal 6x7cm shots, something that would have been inadvisable with 35mm.

Asked to define what it is about his pictures that sell, he talks of tight composition, bright colours, blue skies and landscapes without people or cars to spoil the composition. He usually tries to exclude people from his pictures for calendars. In other markets, such as travel brochures, they help to make a picture sell, but calendars want the scene without any unnecessary intrusions.

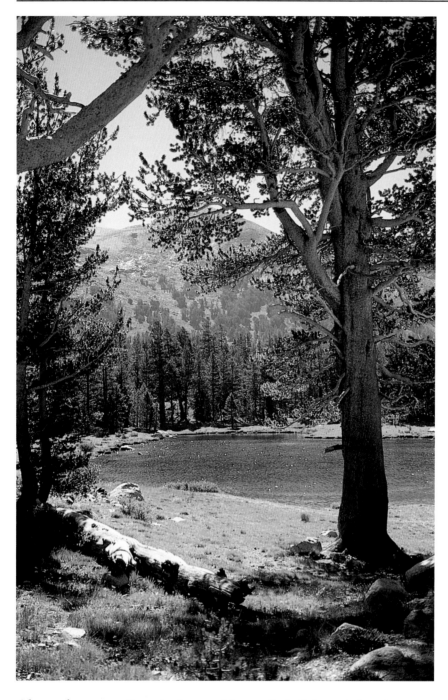

Another example of a typical greetings card subject.

Also, of course, there's the problem of clothing styles that can quickly date a picture which might otherwise sell over and over year after year. The same goes for cars.

When he sends pictures for consideration to a calendar publisher, he will send up to 100 images. If fifty are chosen and the rest rejected, he doesn't automatically assume the rejected pictures are no good. Many times he has sent the previous year's rejections to the same publisher again and seen them used the next time

around.

He finds that some calendar publishers want to put out a calendar that shows a good spread of pictures from around the country. If you have the right area that they are looking for then, your picture might sell on its location as much as its pictorial content. That's why it is important to take a lot of pictures in a lot of different areas.

Dawn and dusk are David's favourite times for shooting, mostly dawn, and he will often use filters in the 81A and 81B bracket to warm otherwise cold tones. He also uses lightly graduated filters to enhance the pictures on occasion. David always uses a tripod and has a Mamiya RB67 with standard, wide and medium tele lenses. For 35mm, he uses a Nikon with a range of lenses from 24mm to 500mm. Pictures, in both formats, that are taken with the wide-angle lenses are the ones which sell most, he finds.

Publishers have told him that he has a style all his own, although he says he can't see it himself. Nevertheless, there are publishers who buy twelve pictures from him for a single calendar, reinforcing the point about getting a single style throughout.

Doing it yourself

Throughout this chapter, we have been looking at ready-made markets for calendars – publishers who buy your pictures for their

Animals and birds can make good subjects for greetings cards as well as calendars.

own products in much the same way as magazines might. But there is another way of publishing pictures on both calendars and greetings cards. You can do it yourself.

On the greetings card side, it is possible to take pictures and have them printed to your own designs, which you can then sell around the shops. But because the big companies print by the thousand and so have got their prices down, you might not find this too cost effective as a freelance. Nevertheless if you come up with an original idea that the big, more traditional companies have missed out on, you might just catch the imagination of card and stationer's shops and start to make some sales.

For information about marketing and how to get your work printed, see the chapter on postcards. The advice offered there on that score applies here as well.

There could be an even better market for home-produced calendars, which you can sell, not to shops (although there's no reason why you shouldn't give that a go in the same way as you sell your own postcards or greetings cards), but to local industry. All you need are half-a-dozen or so companies who require a calendar, some capital and a certain amount of initiative. And twelve good pictures of course.

The trick here is not to sell just one calendar, but to sell the same basic design and pictures to as many people as possible. Start with a basic design concept and twelve suitable pictures. If you have a certain amount of artistic talent, you can probably come up with a design idea yourself. Alternatively, you might want to enlist the help of a graphic designer – you'll find a list of them in your local Yellow Pages.

But when it comes right down to it, a commercial calendar needn't have very much more on it than the name of a local company, a picture and the calendar itself.

So organise a mock-up that has space for the name, logo, address, phone and fax numbers of a company, together with any slogan they might have. Beneath that, you position your picture, simply done by having a colour print made and sticking it into position. Then add a traditional calendar for each month below that.

Now start knocking on doors. Visit local companies and industries. They don't have to be big concerns – the small one-man garage down the road is as likely to buy from you as the enormous factory outside town. The idea is that you sell them all the same calendar, with only the type at the top, featuring their own details, changed each time. Naturally, you tell them what you are doing and explain that producing it this way will keep their costs down. Also, of course, you do not offer the same calendar to two different companies who might be in direct competition.

Get your orders, find out how many they need, ask them if they can supply their own artwork for their personal space or whether they want you to make it up for them. Providing they give detailed descriptions of what they want, the printer will do this on your behalf.

To learn about dealing with printers, once more refer to our chapter on postcards and how to print your own.

Once you have chosen a printer, you tell him how many calendars you want printed in all and how many times he has to change that simple line of type or artwork at the top. He will be able to make up the actual days and numbers of the calendar for you and, of course, this doesn't need to be changed any more than your twelve pictures need to be. The most expensive part of printing any colour job is making the colour separations from your pictures. Once this has been done and the basic printing organised, changing the type at the top of each sheet is only a matter of changing one printing plate, providing you stick to one colour in this area, and that is low cost process compared to the rest of the job. And, of course, the more companies you get involved, the more the unit cost comes down.

Once you have worked out the unit cost – that's the overall cost of the job divided by the number you print in total to get the cost of one calendar – all you do is add your own profit and multiply that figure by the number of calendars each company wants, to give them a price.

The beauty of doing this is that you can also have that line at the top of the calendar changed to incorporate an advertisement for yourself, which will make it a whole lot easier to sell the same idea again next year, and the year after, and the year after that....

MAGAZINES

One of the biggest markets for your holiday pictures can be found in the literally thousands of magazines published in the UK covering every subject under the sun — many of which can be found on holiday.

For the true freelance, the time to look at these magazines is not when you return with your pictures. It's before you leave, looking for those that might cover the kind of subjects that you expect to encounter on your holiday so that you can go away prepared.

In a moment, we'll look at specific types of magazine that will be useful to you, together with a brief analysis of the kind of work you can sell them. But first let's look at the subject of market analysis in general. Here's a brief six-point plan to help you find markets for your holiday pictures, as you take a stroll around your

The more traditional travel magazine wants pictures to illustrate what goes on in holiday areas. The camel market where this picture was taken would make an ideal illustrated article.

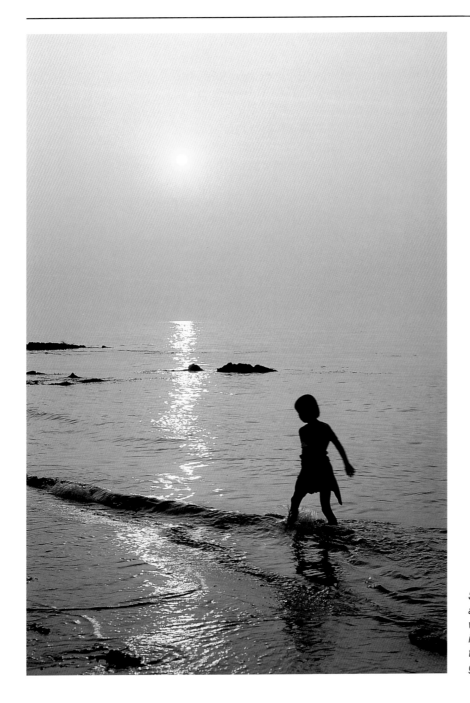

Some magazines like atmospheric pictures with space for the inclusion of titles and the introductory paragraphs of a feature.

nearest large newsagent, before you leave.

1. Start with a general idea of the kind of pictures you anticipate taking and look for magazines that fit in with those subjects. For instance, if you intend to take nothing but landscapes in the UK, look at the countryside and heritage type of publications. If you anticipate visiting areas where there is a lot of fishing and angling, look at the specialist magazines covering those subjects. If you

know of crafts being practised at your holiday destination, look at craft magazines and women's magazines. If you are going camping or visiting areas that attract campers, look at caravan and camping publications. You can apply this line of thinking to all sorts of subjects and holiday destinations.

2. When you have narrowed your thoughts down to a few specific magazines, buy them and take them home so that you can study them in detail. Then look at the magazines, not as a reader might, but the way a freelance does.

3. Look at the ratio of colour to black and white to see which type of picture your intended market uses most. That will tell you what type of film to take away with you.

4. Look to see if the pictures are being used on their own, merely for their pictorial content, or whether they are tied in with features. If the former is the case, you stand a good chance of selling pictures alone. If the latter looks more likely, you'll have to consider whether or not the pictures you intend taking would illustrate any specific point that would form the basis of an article.

5. If the pictures are being used primarily as article illustrations, work out whether the picture subjects are tied in inextricably with the words, or whether they illustrate the subject of the feature in a more general way. For instance, if the article is about, say, a seaside rock factory, it's a fair bet that the pictures tie in strongly with the specific words of that feature. On the other hand, if we were looking at an illustrated feature on the charms of a certain English city, like York perhaps, then there's a chance that the words were written by a freelance writer with the pictures added from the magazine's files. If the magazine operates in the first of these ways, then you will sell your pictures only if you supply an article with them. If the second option looks more likely, then you could supply sets of pictures with a common theme but with no more than captions to accompany them.

6. Look to see who is supplying the material to the magazine, by checking bylines on pictures and articles against staff members listed on the contents page. Many magazines work with quite a small in-house staff, relying on freelances to supply their needs, in which case there could be a market for both words and pictures from you. Others get their staff to write all the features to a specific style, but illustrate those features with file pictures from freelance photographers and agencies, in which case there's a market here for pictures without words. Luckily for all of us, very few magazines – as opposed to newspapers – actually employ a staff photographer.

If you use that six-point plan to analyse your prospective markets before you leave, you'll have a much better chance of taking

the kind of pictures that make sales once you get to your holiday destination.

Let's take a look, now, at how that philosophy works with some of the many different types of magazines on the market.

Travel magazines

We'll start with what must be the most obvious market for the holiday photographer. Travel magazines tell readers what to expect on holiday, so it's obvious they need pictures taken on holiday.

Mostly, travel magazines want two types of picture. First, there are general pictures of typical holiday locations and people enjoying themselves on holiday. These might be kept on file for use with short reports by staff writers, to illustrate features written by freelances who do not have pictures, and for use on news pages.

The second type of picture bought by the travel magazine market is the article illustration. Here, rather than just supplying pictures, you will stand your best chance of success, sending the words as well.

So, when you are on holiday, take pictures that actually show readers something definite about a holiday area. Take pictures too of the people around you enjoying themselves, and don't be afraid to ask them to pose for you. Candid pictures of people in the distance, with their backs to you or half-turned away from the camera, won't sell. Posed pictures of people in close-up, laughing and smiling as they drink in a bar, frolic on the sand or splash in a swimming pool will stand the best chance of success.

Remember that holiday magazines are read by people who want to feel an attraction to a certain area, and that they won't feel that way if you take your pictures on dull days. Although you might get away with a few impressive night shots in this market, the vast majority of sales will come from pictures taken in bright sunlight and with lots of blue skies.

County magazines

Nearly every county in Britain has its own local magazine. You might be familiar with the one that is published for your own county, but don't forget that for those holidaying in the British Isles, there will equally be a county magazine serving your holiday destination as well.

Such magazines vary from county to county, but generally, they are small publications, put together on a limited budget, with more use for black and white than colour. There is a market for good colour pictures of picturesque subjects taken within the county for the cover, while inside, there is scope for articles about

local people and places, mostly illustrated in black and white.

Depending on the individual magazine, there might also be a market for a few one-off local landscapes, used without words and purely for their pictorial content.

Walking and rambling magazines require pictures like this to illustrate the route of a particular walk.

Countryside magazines

Do not confuse these with county magazines. Unlike those local publications, these are published nationally, covering the whole of England, or the whole of Scotland or even the whole of the British Isles. Make sure you differentiate between them. A magazine with a title like *This England* is not looking for pictures of Wales or Scotland.

Having established that in your mind, you can treat these publications like more professional and wider-ranging versions of county magazines.

They need covers that show the country in its best light. They often go for one-off pictures inside which also show the pictorial merits of the English or British countryside in a very traditional, chocolate box type of way. Equally, they use pictures to illustrate articles about the country they are covering, its traditions, history, crafts, curiosities and nostalgia.

When dealing with these magazines, however, do not forget you are aiming at a national, rather than a local, readership. An

If you are holidaying in the UK, subjects like this might sell to the local magazine of your holiday county. They often use features on interesting places within their area.

article about Joe Bloggs, the local thatcher, might go down very well in a local county magazine, but on a more national basis, where Mr. Bloggs would not be known and without the local angle, there would be less chance of success, unless there was something particularly unusual or different to say. On that score, it would be better to put your thatcher with others like blacksmiths, coopers, etc. and produce an article on something more like the

forgotten or dying businesses of Britain.

Walking and rambling magazines

Here's a very good market for holiday landscapes, providing you handle things in the right way.

Take a look at the magazines that cater for this type of readership and you'll see that, once again, they do not merely use pretty pictures for their own sakes. The landscapes are there for the very definite purpose of illustrating specific walks that readers might like to try.

So, to cover this market, it's no use taking one landscape picture in one place, another ten miles away and a third somewhere entirely different. Your pictures have to be taken in one small area, linked by the fact that the reader can see these views when he or she takes a specific walk. The best way to do that, of course, is to take the walk yourself, making notes along the way so that, later, you can write an article that links the pictures in the way that the magazine prints its articles.

It's also a good idea to include actual walkers in your pictures. They can help with picture composition, and they also help the reader, keen to walk in the place you are illustrating, relate to the area better.

When taking pictures with this market in mind, don't hesitate to turn the camera sideways and take a few vertical shots. This is a good market for cover pictures showing walkers in picturesque locations.

Camping and caravanning magazines

The market here is a little like the walking and rambling market that we have just covered. Campers and caravanners like to see picturesque landscapes of places where they can camp. But they also like to see something of the facilities on offer for them. So don't be afraid to take pictures of actual camp sites, especially if they are in a particularly beautiful setting.

If you are a camper or a caravanner yourself, you'll have a strong advantage, but you don't have to own a caravan or a tent in order to shoot pictures of them, whether it be on camp sites or in some remote area that you feel would make an interesting picture. A quick word with the owners of the tent or caravan you wish to shoot will undoubtedly help you to get the best pictures, since you might then be able to pose them going about their holiday duties in a way that will make your pictures more interesting.

As always, look at the magazines before you go, to see if your target market wants only pictures that illustrate articles on specific

places or whether they seem to be using file shots of campers in general. And don't forget the possibility of cover pictures, showing campers and caravanners in interesting locations.

Waterways magazines

The canals and rivers of Great Britain are popular holiday resorts and there are several magazines catering for people interested in this type of holiday, whether they own a boat or are just hiring one for a week or two.

While such magazines might run features on the care and upkeep of boats, there is equally a market here for telling readers, by way of words and pictures, about stretches of water they might like to visit. So treat this market the way you would the one for walkers and ramblers. The only difference is that you are dealing with stretches of canal or river that the hobby boater can get to, rather than stretches of land that the rambler wants to walk across.

The photographic press

Here's a market that has changed tremendously in just a few short years. Once the magazines wanted lots of illustrated articles from freelances; now most of the words tend to be written by the staff, using freelance pictures to illustrate them. Once the magazines wanted mostly black and white; now they use predominantly colour. Once they printed articles that were long and intricate with only a few pictures illustrating the words; now they use pictures far more, cutting words to a minimum.

All of which is good news for the freelance photographer. It means that the magazines are constantly on the look-out for pictures to illustrate features written by staff writers and to pass on tips to readers about taking better pictures.

That last point is the key to this market. The pictures that sell are those that illustrate a definite photographic technique, and that can be either aesthetic or technical.

On the aesthetic side, your pictures might show things like examples of composition, the use of light, or good examples of traditional subjects such as landscapes, portraiture, still life, action, etc. On the more technical side, we could be dealing with things like the use of different types of lens, filters, close-up accessories, the techniques of multiple exposure, etc.

When you send pictures to the photo press, try to shoot comparison pictures. In other words, don't just take a shot with a polarising filter and send that in on its own. Instead, shoot one picture with the filter and another without it. That way the reader can see the real effect of using that particular type of filter. What's

more, you will be able to see if the effect is pronounced enough to be worth illustrating.

Women's magazines

The range of women's magazines on sale in the UK is vast, bigger than for any other specialist interest. Every magazine is different in some way from its neighbour and it's wise to study specific magazines before making submissions. Even so, there are a few general areas where many of them overlap, giving you a place to start as you begin your analysis of this extensive market.

It's a market which, like the photo press, has changed somewhat over the years. At one time, all women's magazines were full of in-depth features on various subjects that appeal to women, with only a small market for pictures. Because the market is so vast, there is room for that type of magazine to still survive and sell. But the newer breed of women's magazines are the one that will appeal more to the freelance photographer.

In these, rather than use long, detailed features, they tend to break everything up into small chunks, each one illustrated by a picture, much in the same way that some of the better selling photo magazines do. Here, you will find a market for curiosity pictures, especially those that are concerned with animals or unusual places of interest – all of which can be found when you are on holiday.

Is there a camping or caravan site close to your holiday destination? There was one near this location in Scotland, helping it to sell to a specialst magazine.

Many women's magazines run travel features, especially at the start of the year when readers are booking holidays. So here too is a market for illustrated articles on holiday destinations that might be a little out of the ordinary.

One subject that a lot of women's magazines are interested in is children. Many will keep such shots on file for future use. Once again, holidays can be the ideal place to shoot that particular subject, but don't just take pictures of kids in standard holiday snapshot poses. Shoot them involved in games and at play. That's the sort of approach that wins sales.

Almost any picture you take on holiday can be sold to the photo press if it demonstrates an identifiable photographic technique, such as, as in this picture, the use of a super-wide lens.

Sailing and boating magazines

Many newcomers to freelancing take attractive pictures of boats and immediately hope to sell them to boating magazines. Sometimes they do, but the occasions when they fail are those when the picture has lacked the necessary sense of purpose.

Readers of boating magazines are already knowledgeable in their subject. It's no use just showing them a pretty picture of a harbour full of boats. It might be pretty, but the reader has seen it all before and it doesn't tell them anything new or different about their own specialist subject.

Another problem faced by those trying this type of subject is that, when you are on land, boats are often too distant to really fill

the frame without the use of an extra-long lens. Small dots on the horizon are no use to this market either. You'll get your best pictures, then, from other boats. The closer the subject, the more the impact and the better are your chances of making a sale. That's the case even if, strange as it might seem, moving close means chopping off the top of a mast.

Readers want to learn about what's new in the boating world, and they'll get that from pictures supplied to the magazine by the boat building companies when a new model is launched. So once you see a boat on the water, it's already too late to suggest it as a news item.

There is also a market here for people involved in the various activities associated with sailing and boating.

Fishing and angling magazines

As with the previous market, remember that your readers are already knowledgeable about their subject. If your pictures are going to sell, you must tell them something they don't already know. Hence, a pretty picture of a fisherman in the sunset might not be relevant, whereas a picture of that same fisherman at a location readers might not have heard of, but would like to know more about, suddenly becomes more saleable.

Most fishing and angling magazines are about where to catch fish and how to catch them – so that's what your pictures must reflect, going always for the straight record photography approach to the subject, rather than the perhaps more tempting artistic approach.

Since your readers are experts, you must not try to fool them with generalities. If you show a fisherman with his catch, the reader wants to know exactly what type of fish you are illustrating. If you don't know, ask questions. Supply captions that are dead accurate.

Also remember that there are different seasons for fishing. So, if you shoot a picture in August, it might be September before you have returned from your holiday, had it processed and submitted to a magazine which, by that time, is thinking about its November and December issues. Moral: shoot now, submit later when the time is more appropriate.

Railway magazines

Holidays, particularly those taken in the UK, often include areas where there are old steam railway preservation lines. For the freelance who is prepared to do a little homework, they can be a mine of good saleable pictures.

But, as is the case with so many specialist magazines, never underestimate your reader's current knowledge or thirst for more knowledge. A picture of a railway engine on its own says nothing. The same picture, accurately captioned with all the technical details of the engine, what class it is, its number, the line it is running on, the date, where it is going and why... all this will show an editor that you know your stuff, and get you the best chance of a sale.

There are quite a lot of news pictures to be had in this area of interest – new lines opening, old lines closing down, engines which have been refurbished and which are coming into service for the first time in years, others that are being taken out of service. All of this is of interest to the railway enthusiast, but if you are going for news, remember it must be up to date. You must be telling readers something that has literally only just happened, not something that happened a few months previously. And, having taken your picture and got together the most accurate caption for it, you need to get everything submitted as quickly as possible.

Readers of these magazines are not interested only in trains either. They are interested in all the paraphernalia of the railway world – signal boxes, signals, coaches, railway architecture, the people involved with the railways.

Also, unlike some other specialist interests, this is a market that likes the artistic approach to the subject as much as the straight record shot. Remember, though, that even if you are photographing a train in the distance, crossing a picturesque viaduct, the reader still wants to know all those technical details that only you, the person on the spot at the time the picture was taken, can supply.

Motoring magazines

The travelling photographer probably isn't going to be much concerned with the majority of pictures seen in motoring magazines – pictures of new or classic cars with their associated reports, or pictures that show how to make repairs. But there is an area of the motoring press that can be useful to the travelling freelance.

Many of the motoring magazines buy one-off curiosity or funny pictures with a tenuous link to motoring. Amusing or off-beat road signs are the obvious subject matter here. There might also be a market for pictures of accidents, although you should be careful in this case not to offend anyone with your photography and not to identify people in vehicles involved. Steer clear, in these circumstances, of number plates appearing in the picture.

There are a lot of big glossy magazines for motorists, but you might find it better in this market to aim at some of the smaller,

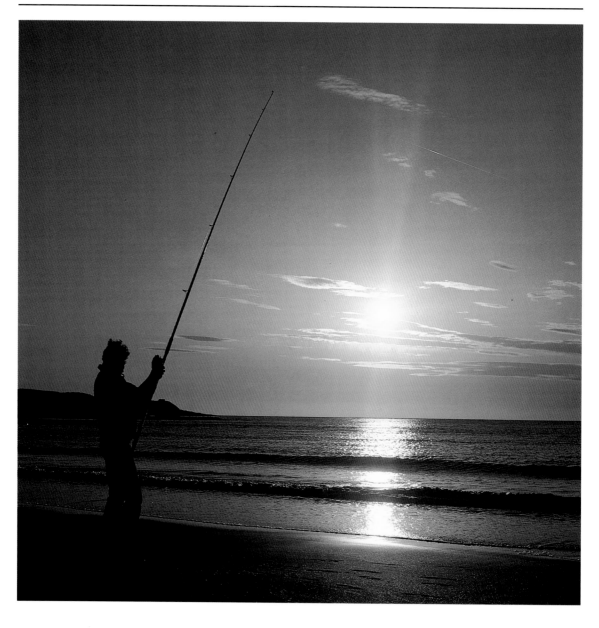

more specialised titles – magazines for driving instructors and even insurance companies, for example.

Gardening magazines

Many holiday resorts contain public gardens, where you might be able obtain pictures of blooms otherwise unobtainable in your own or any other private garden. They can be of use to gardening magazines that need to build up comprehensive files of the many different plants or flowers that interest their readers.

If you are going to try this, make sure you move in close to really fill the frame with the flower. Use a small aperture because

Find a dramatic angle on a well-known subject and you might sell to a specialist magazine, such as one dealing with sea angling. A picture like this makes an ideal cover shot because it is colourful, has impact, shows the specialist subject and still leaves room for the magazine's title and coverlines.

depth of field decreases at close focusing distances and you will stand less chance of making a sale if half the subject is out of focus.

Most important of all, check that you have the name of the flower or plant you are photographing, both its common English name and its Latin name, both of which will probably be detailed somewhere in the vicinity of the plant you are shooting. Don't rely on the fact that the editor will be able to recognise every bloom that falls on his desk. Make sure you get and supply the full details for the best chance of selling pictures of flowers.

Gardening magazines need stock pictures of flowers – but make sure you know exactly what species you are photographing.

Craft magazines

Holiday destinations often lead you to people involved in local crafts, and there are magazines around to tell readers how they too can practice these different crafts. That's the important thing here – the fact that your pictures, and any written information you add to them, must educate the readership in some way, not only showing them the craft, but also explaining how they can try their own hand at something similar.

This market, then, does not cater for the sort of general picture that you might take at a craft show, candidly or from a distance showing, for example, someone working a spinning wheel. On the other hand, if you come across this kind of subject, talk to the peo-

ple involved, ask them questions and see if they have any literature on the craft that might later help you to supply technical details. Then take pictures from several different angles that will go towards showing your reader a step-by-step guide to tackling the craft.

The information you've just read isn't meant to be a definitive description of what each and every magazine market specifically needs, but more of a guide towards the kind of magazines that might interest you, according to your own preferences in photography, and to help you decide what kind of area you should be aiming at.

So use this guide to narrow your own thoughts to perhaps just one or two markets. Then go out and buy a few magazines to check their style against the six-point market analysis plan that we started with. That way, you can move from the generalities mentioned above to the specific needs of your chosen market.

The freelance who understands those needs before the pictures are taken is the one that makes the most sales.

PICTURE AGENCIES

As a freelance photographer, selling your own pictures direct, you will find many markets open to you. Yet, there are many more that are difficult for an individual working alone to find. Who takes the pictures on biscuit tins and jigsaw puzzles, for example? These are just two of the many extra markets that most often will be buying pictures not from individual photographers, but from picture libraries or agencies. What's more, those same libraries will be supplying travel brochures, calendars and greetings card publishers as well: markets that whilst approachable for individuals will often favour the easy way out and buy from a library.

Why easy? Because there are a lot of amateur, would be freelance photographers out there who haven't your knowledge and therefore never come close to supplying the right kind of material. For every submission that falls through a picture buyer's letter box, full of excellent pictures, correctly exposed and taken on the right format, there's probably another 90 that fail miserably to come anywhere near the buyer's requirements. In the end, rather than wade through all that dross, looking for the gems, it's easier for them to visit a library, where every picture has already been vetted and filed in such a way that buyers get exactly what they want, sometimes within minutes of sitting down at a lightbox and having the first sheet of transparencies dropped in front of them.

Picture libraries specialise in stock shots. The kind of pictures which the buyer uses to set a scene in some way. The obvious places where library pictures end up are all those markets we have already mentioned: travel brochures, greetings cards, calendars, magazines, even jigsaws. To those you can add other areas in which, as an unknown freelance, you would stand very little chance of success on your own: markets like advertising, book publishers, business brochures, annual reports, audio visual presentations, even television companies looking for stills.

What's more, if you take a look at the files of the average picture library, you'll find that an extremely significant percentage of their pictures feature the kind of subjects that can easily be found and taken on holiday: landscapes, seascapes, cityscapes, people, children, glamour, cars, sporting action, sunsets, waterfalls, fire-

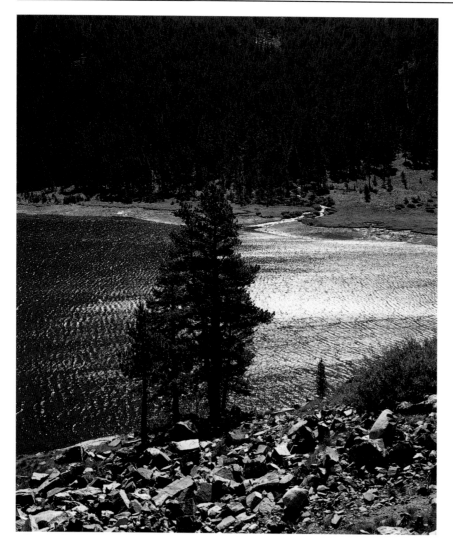

Quality landscapes are always demanded by picture libraries. They might easily sell them to a travel company that wouldn't otherwise deal with you direct.

works, flowers, trees... the list goes on and on.

How libraries work

There's a common misbelief that only professional photographers stand any chance of getting their work into libraries. It's true that many of the pictures in libraries are taken by professionals, but that's only really because they take a professional approach to their work. Any competent amateur who is capable of acting like a professional stands just as much chance of success.

For the purposes of this book, a dozen British libraries were surveyed and every one said they were prepared to consider work on spec from any photographer who could match their needs.

That means that you must supply the agency with the kind of pictures they can sell. Don't run away with the idea that agencies are in business to sell your failures for you, the pictures that you

can't sell for yourself, or for which you can't think of a market. It's true that they will sell pictures to markets you might not have thought about, but they still need commercial pictures and you have to learn what they want. More about that in detail in a moment.

The other thing they need is quantity. No library or agency worth its salt is going to consider just one or two pictures from you, the way a magazine, a travel brochure or a calendar company might. They need to know that you are serious in your work and that you are going to be as profitable to them as they are to you. That means that, in the first instance, they are going to want to see a few hundred pictures from you and, if they like what they see, they could demand a commitment from you to keep supplying them with pictures on a regular basis.

Once you have shown them that you can supply the kind of pictures they need, then you will be taken on to the agency's books and your pictures placed on file. You might not hear from them after that for some time, but don't think they have forgotten you. Picture libraries hold extremely large stocks and it would be the exception rather than the rule if they started selling your pictures right away, since clients visiting the agency to find pictures have the work of a lot of different photographers to choose from. For that very reason, it is in your best interests to keep supplying as many pictures as possible. The more of yours they have on file, the more likely you are to make a sale.

A good stock shot that any agency would be pleased to have. Markets could vary from the obvious travel publications to something more unusual like a jigsaw company.

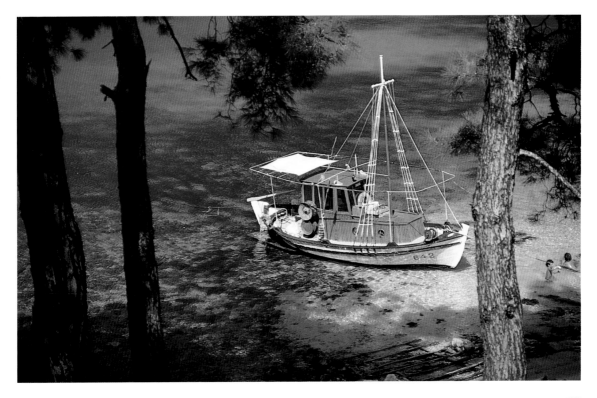

When some of your pictures do sell, you will be paid your fee. This usually arrives on a six-monthly basis and the vast majority of libraries keep 50 per cent for themselves. If you think that's a little on the high side, then consider what you are getting for your 50 per cent. The library looks after your pictures, files them, numbers them, often remounting and even duplicating them. They have running costs on the building they occupy and staff to pay. Also, of course, they stand a good chance of finding markets that you would not have found for yourself, as well as selling your pictures more than once. Take all that into account and you'll realise that 50 per cent is a very fair fee.

Finding a library

It is not the purpose of this book to list every library and picture agency in the British Isles. For that, you should turn to *The Freelance Photographer's Market Handbook*, published by BFP Books. Here you will find names and addresses of reputable libraries, together with their requirements. Notice the use of the words reputable and requirements. They are two Rs that are particularly worth thinking about when you first set out to look for a library to handle your work.

Not all libraries are reputable. There have been instances of people setting themselves up as a library as a means of making a swift profit without any serious attempt at selling pictures. How do they do that, you may well ask. Easy: they charge you a registration fee for joining the library.

Generally speaking, if you come across a picture library, agency or any other organisation that claims it will sell your pictures on your behalf but wants a fee from you to register, then you should tread extremely carefully. If picture libraries are any good at what they do, they make their money from the commission they charge. They have no need to ask for any kind of fee in advance.

You sometimes see certain organisations, asking for a registration fee and promising to sell your work, advertised in amateur photographic magazines. The best advice is to avoid them. Legitimate and genuine picture libraries would rarely advertise their services in amateur magazines, although you might find them in professional photo publications. You'll also find them listed with their current requirements in monthly issues of the *Market Newsletter* that is sent to all members of the Bureau of Freelance Photographers.

If you want to be absolutely sure if you are dealing with the right kind of agency, ask them if they are a member of any professional body. The majority of the best libraries are members of BAPLA – that's the British Association of Picture Libraries and

Agencies. There are a few good and reputable agencies around who are not members, but if you want to be absolutely sure that you are dealing with the genuine article, you can't beat going for one that is a BAPLA member.

The other R is for requirements. Like magazines, most agencies handle their own specialist subjects. Granted that their subject lists are much wider than the average specialist magazine, but nevertheless, you should know who you are dealing with and what they need. Some agencies, for example, specialise in wildlife, while others specialise in sport. The majority, however, are looking for the sort of pictures that could be taken on holidays. So do make sure you know the requirements of the agency you are about to approach, otherwise you could be wasting their time as much as your own.

Another typical travel shot that the right agency might find a home for. Apart from obvious markets, a 35mm slide could sell to an audio visual company for use in a business presentation.

What they want

With only a very few exceptions, just about every photographic library or agency wants colour. And they want it in the form of transparencies, not prints. At one time, no agency would even consider 35mm, demanding 6x6cm originals at the very least. Times change. Today, photographers stand a good chance of having 35mm work accepted, although it must be said that given the choice between a 35mm slide and a medium format transparency

of the same subject, the larger format will win out every time.

The very best quality is demanded of all work sent to agencies, so if you are aiming to deal with one, read the chapter on A Question of Quality very carefully. Also take note of ways of working covered in the chapter on Basic Techniques. Agencies are usually dealing with top-class customers and clients who know what quality is all about. If you don't supply that quality in the first place, you will stand little chance of success with an agency.

That means that you should almost always avoid dupes. It is possible to have good quality duplicate transparencies made professionally, and if your own techniques are good enough, you might be able to produce them yourself. But you won't do it with one of those inexpensive slide duplicators that fit to a SLR in place of the lens. They are fine for some kinds of copying and very useful for special effect photography that might find a home in the photo press. But they inevitably increase contrast and often involve a colour shift that a picture agency simply won't accept.

So what do you do if you don't want to tie up your precious pictures for the length of time that an agency wants to keep them on file? Simple – you make sure you shoot more than one picture at a time in the first instance.

That might sound wasteful if you have never been involved in picture selling before, but ask any professional photographer and they'll tell you that it's extremely worthwhile. Once you start to take and sell the kind of pictures that make money, you'll want several different versions on file for your own use, for different markets that might need the same picture at the same time, and to cover the eventuality of transparencies getting lost or damaged in the hands of clients.

Subjects that sell

Picture libraries and agencies deal mainly with what are called stock pictures. They are standard pictures, filling the frame for maximum impact, of almost any subject, shown in a straightforward, competent manner rather than in the more artistic way that the creative amateur, without any markets demands on their work, might shoot.

There are, of course, agencies that deal with, and some which even specialise in, the more creative approach, in which the photographer has used multiple exposures, unusual filters or other special techniques. But generally speaking you will stand the best chance as a beginner approaching an agency by treating everything in as straightforward a manner as possible.

Look, for example, at the kind of still pictures that you see used on television. You didn't know TV used stills? What about

the identification pictures that flash on the screen behind the news readers on News At Ten? Sit and count how many of those you see used briefly on each evening's bulletin, and look at how straightforward they are in both their approach and their subject matter: Well-known landmarks from the UK and overseas from different angles, a street in London or Paris or Rome, buses, cars on motorways, children at play.... they are just a few of the pictures that you might see in any one broadcast. They're all the kind of pictures that you can take on holiday and they have ended up in a marketplace that would almost certainly buy its pictures only from agencies.

Look at other markets that we have already dealt with in some detail and which deal with agencies as well as directly with photographers: calendars, greetings cards, travel brochures. They are all full of the most straightforward pictures, shot in a simple, conventional manner.

Other markets that agencies can find on your behalf – markets that you might find difficulty finding for yourself – include advertising agencies, who need scene-setting pictures to help advertise a vast range of products; audio visual companies, who produce sophisticated 35mm slide shows to launch various products; record companies, who need pictures for records, tapes and CDs; and book publishers.

This latter market is particularly pertinent for several reasons. It is often difficult for the individual photographer to sell successfully to a book publishing company, since you'll rarely be able to discover what kind of subjects they are working on at any one time. An editor will decide to produce a book on, say, the architecture of Greece. There's very little hope of individual photographers getting to hear of these decisions or picture needs and so be in the right place at the right time to come up with the right pictures. What happens is that the editor simply visits several libraries and says: "Show me everything you have on Greece." So, if you have placed your pictures of Greece with an agency, and depending on what you have in their files at the time, the finished book could contain a very high percentage of your pictures.

The kind of stock pictures that agencies deal with treat picture composition in three different ways. The first is the most obvious: framing the subject so that it fills the frame perfectly without any wasted space or empty, uninteresting areas. But there is another approach that is worth bearing in mind at the same time. A lot of agency pictures are sold to top-class editorial markets that need them to set the scene for a written article. As such, the client sometimes likes to use the picture in conjunction with words: the title of a feature across the top of the picture, an introductory paragraph of the feature itself printed over, or reversed out of, the lower half

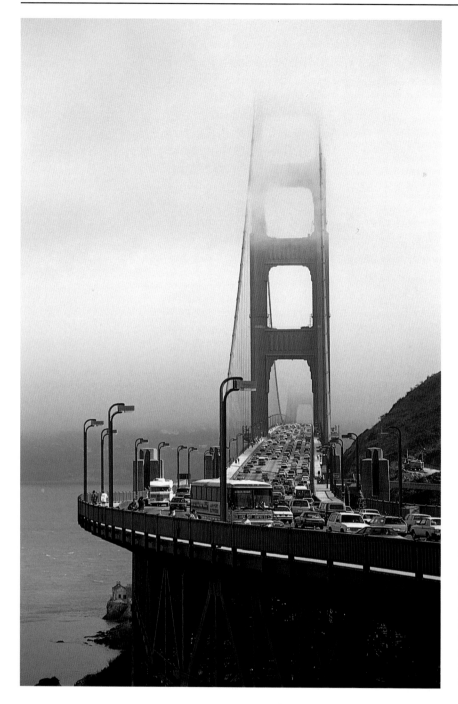

Unlike the traditional travel markets, libraries won't always want to see everything shot in bright sunlight. A picture like this that actually sums up the location better than a sunshine shot would is often of more importance to a library.

of the picture. For that reason, it's a good idea to shoot some stock pictures with this in mind, using a looser composition where only the centre part of the frame is filled with the subject, the lower and top sections comprising blank areas, such as sky, grass or water.

The third approach is for pictures that the agency is selling for cover use. In that case, the picture buyer wants a vertical shot, possibly with space at the top for the title and, in the case of maga-

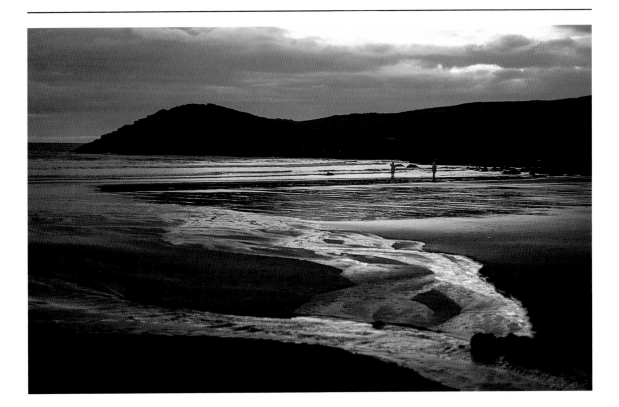

zines, often space down one side for coverlines – the few words that give a hint of a publication's contents. Coverlines are nearly always on the left hand side of the cover, so that they can be read on a newsagent's shelf when magazines are arranged overlapping one another. That being the case, it's an equally good idea to shoot with the main centre of interest in the bottom right-hand segment of the picture area, leaving space at the top and on the left.

Similar thoughts should be applied to pictures for record, tape or compact disc covers.

But wait a minute, you cry, make up your mind! Should I shoot with the subject filling the frame, smallish in the centre or off to one side? The answer, when the subject allows for it, is to shoot all three. An agency won't mind looking at three different approaches to the same subject, if they think they can sell at least one of them. Better that than to have only one version, and the wrong one at that.

Despite what we've said about straightforward, record shots, there are, of course, markets within agencies for special effects, but mostly these will be of the computerised image type of approach – pictures that will be used in hi-tech markets, and not really the sort of thing that concerns us here.

So your keywords when shooting stock pictures are simplicity, conventionality and, above all, quality.

Libraries like the different approach. Dusk isn't usually the time to shoot on a beach, but doing just that could make you a sale through a library.

Approaching an agent

Treat agencies in the right way and they are very approachable. After all, without your pictures they wouldn't have a living. What they won't do is spend time giving you advice. That's not what they are in business for. If they stopped to analyse every picture that came through the door, telling photographers why they are rejecting them, they wouldn't have time to go about the day-to-day business that makes money for themselves and their photographers.

So don't contact an agency until you are absolutely sure that you have something worthwhile to offer them. Having found an agent who handles the kind of subjects you have been shooting, or aim to shoot, your best bet is to write or telephone and ask for their guidelines. Most agencies have an information sheet that tells you exactly what subjects and the kind of approach that works for them. You can use this to double-check that you have picked the right agent for your photography.

Once you are confident that you have the sort of subjects they require, you can telephone and ask if they would like to see your pictures. They may tell you to put them in the post, in which case do so, together with a covering letter referring to your phone call. If you register the parcel at the post office, its contents will be insured, so you needn't worry about losing the pictures. Alternatively, they might ask you to come in with your portfolio and show it to them in person. Either way, you have to make sure that first impressions count for you.

This is the time to be totally ruthless about your photography. Look through the pictures you aim to show the agency and pick out only the best. Don't hesitate to throw out any that are over-exposed, badly under-exposed or unsharp. Pick only those with good colour saturation, on well-lit subjects that fill the frame in the various ways we have described.

Now divide your pictures up into themes. Put all the landscapes together, all the people shots, all the pictures of buildings, etc.

Next, put 35mm and medium format slides in plastic filing sheets that allow a number to be viewed at one go on a light box. Take a look at your slide mounts. If they are tatty or if they have been written on, then remount the slides.

The way you arrange your pictures in the sheets can also give a good impression. Don't mix vertical with horizontal pictures, don't include pictures of different densities on the same sheet – night shots with sunny landscapes, for example. Also, if you have been shooting different approaches in the way you fill the frame with the same subject, then put all one type of approach in one fil-

ing sheet, another approach separately in another. All these points help to show the agency that you are professional, serious and mean business.

You should end up with at least 100 pictures, all top quality. Only now are you ready to make a submission or a visit to a picture library.

After acceptance

Once you have been accepted by a library, there are certain things that you should then do to keep up a good working relationship.

The first is to show them that the pictures you have had accepted were not merely a flash in the pan. It is in both their interest and your own for you to keep up a steady flow of pictures at regular intervals. But if the selection that you showed them to gain acceptance was the result of twenty years work, and you don't think you can come up with more of the same in the near future, then perhaps agencies are not for you.

On the other hand, if they have accepted a major part of the pictures that you took on this year's holiday, then there's every reason to believe that you can repeat the success after next year's trip.

Anyone who has pictures lodged with an agency must also learn to be patient. Profits can be steady, but they are rarely enormous and hardly ever overnight, unless you are lucky enough to have one of your pictures accepted by a major client looking for a still for their advertising campaign, for example.

It's more likely, however, that your pictures will be sent out to editorial markets, calendar companies, greetings card publishers and the like, from which the agency will receive a modest but worthwhile fee and you will receive half after their commission.

You won't get paid after each sale either. Instead, the agency will set up a system of paying you at regular intervals, most likely every six months, when you will discover what, if anything, has sold in the past half year.

If you have had pictures accepted and haven't heard anything, don't worry the agency. Once you have assured yourself on having picked a good, reputable library, then place your trust in them. If you ring them once a month to find out how your pictures are getting on, or why you haven't had any money, they'll soon grow tired of you – and your pictures.

Remember that agencies rarely force a sale themselves. It's far more likely that clients are coming to them, looking for specific pictures, and if they don't like yours, there's nothing the agency can do about it. They'll do their best for you, but they can't force a sale where no market exists.

Once you do start to make sales through an agency, however, you'll soon get an idea of what type of picture they handle best among their known clients, and then you can increase your chances of success by shooting more of the same.

Another important point is to make sure you don't upset the agency. The easiest way of doing that is to sell pictures yourself which are very similar or identical to those already placed on file. Yes it is a good idea to keep dupes, but be careful about using them in this way if you don't want to alienate the very people who are working hard on your behalf.

When the money does come in, there is every chance that it will be proportionate to the amount of pictures you have with the agency, since the person who has a lot obviously stands more chance of being selected than the person who has only a few on the files – another good reason to keep those pictures coming once you have been accepted. The more pictures of yours that are lodged on an agency's files, the more chance you have of making money from your holiday pictures.

ADVANCE PLANNING

The kind of holiday you take will directly affect the profit you make from it. While all holidays give you some scope for freelance photography, it is undoubtedly true that the more you plan in advance, the more sales you stand to make when you come home.

Advance research

Very little ever happens by chance for the true freelance. Naturally there will be times when you come across the unexpected and know instinctively that a good potential sale has landed in your lap. But, for the best chances of success, you should always plan ahead.

Check out specific attractions in the areas you are visiting. A dolphinarium can make saleable pictures and illustrations for travel markets.

Most people book their holidays at least six months before departure, so use that time to investigate the area you are going to. Visit your local library and get out books on the place you are vis-

iting. There are two types of travel book. One is very wordy with few pictures, the other is more of a picture book. Borrow both.

The wordy book is the one that will tell you the places of interest, with details of local museums, crafts, customs, festivals and the like, many of which can make subjects for your camera. It will also describe, even if it doesn't illustrate, local beauty spots and tell you how to get there.

The picture book can be used first to find places that are going to make suitable pictorial subjects for your camera, and secondly to give you inspiration. If you see a certain view taken from a specific viewpoint that makes a particularly effective picture, then keep it in mind and don't be afraid to copy the idea when you get to your destination.

Tourist offices are also good places to get information. If your holiday is being spent in the UK, a phone call to the town hall closest to where you are visiting will put you in touch with a publicity department that might be able to help you directly, or with the local information point for tourists. You can get the number from Directory Inquiries.

If you are going abroad, then the country you are visiting, as well as individual cities, will also have their own tourist offices that are worth contacting. Again, a phone call is your best bet and, providing you know what city in which country you need, you'll usually be able to get a phone number from International Directory Inquiries. Because they are used to dealing with tourists, you have a good chance of finding someone on the other end who speaks English.

Whether you are dealing with tourist offices at home or abroad, you need to ask for the same basic information. You want brochures on local places of interest, which they will be only too pleased to send you. Within those brochures, when they arrive, you'll find a mine of information that will point you towards picturesque places for pictures, as well as useful leads for possible feature material.

There are many different types of holiday, all of which should afford some chance to take saleable pictures. Some, of course, give more opportunity than others. So, if you are intent on profiting from your holiday, start by choosing the right kind.

Package tours

You can take saleable pictures on even the most unpromising holidays. Take one of those trips put together solely for the sake of sun worshipping, the kind that takes you to a destination consisting of little more than a beach, a strip of concrete and a hotel behind it. A holiday of that type might limit your freelance activities some-

what, but there will still be a certain amount of potential. Beach pictures, people enjoying themselves in the sea, happy couples around the swimming pool, eating barbecues, drinking at open air bars... they're all the kind of shots that can sell to travel brochures, and the locations will be there for the taking in even the most basic of package tours.

Look at brochures to see the kind of filler pictures that are being used. Think of ideas and poses to shoot while you are away and make notes about them. It's not a bad idea to even cut out pictures that you see in travel brochures and stick them in a notebook of your own as a guide to picture ideas when you get on holiday.

Most package tours offer excursions to local places of interest, and many brochures tell you in advance the kind of sights you'll see there. Look through these carefully before you leave and, if necessary, do some research. If, for example, the brochure tells you that there is a visit to a famous archaeological site as an option, give it some serious thought. Maybe it's not the kind of trip you would normally take on a holiday, but it is the kind of experience that could produce saleable freelance work.

That being the case, do some further research in advance. Visit your local library and read up on the history of the archaeological site. Get to know what will be there in advance. Be prepared for the kind of pictures you will be taking. Then, when you go on the trip, you will have the kind of information at your fingertips that could lead to a sale to a travel magazine.

Many package tours also offer excursions in the shape of boat trips. That's another situation where you can shoot people enjoying their holiday.

The main point is that before you leave, you should have a good idea of what is going to be on offer on your holiday. If the brochure you are using doesn't list trips available in advance, make sure you attend the welcome party that tour operators always organise for the first evening or the next morning. That's where your courier will outline what's available over the next couple of weeks.

Either way, look at these trips through the eyes of a freelance, rather than as a typical holidaymaker. Examine the potential for photography and finding feature material, matching it up against what you have already learnt about potential markets.

Organised tours

This second type of holiday is probably the worst for the freelance, because it leaves you relatively little time to yourself. On many of these holidays you are regimented from place to place, spending most of your time on coaches, the only opportunity for photogra-

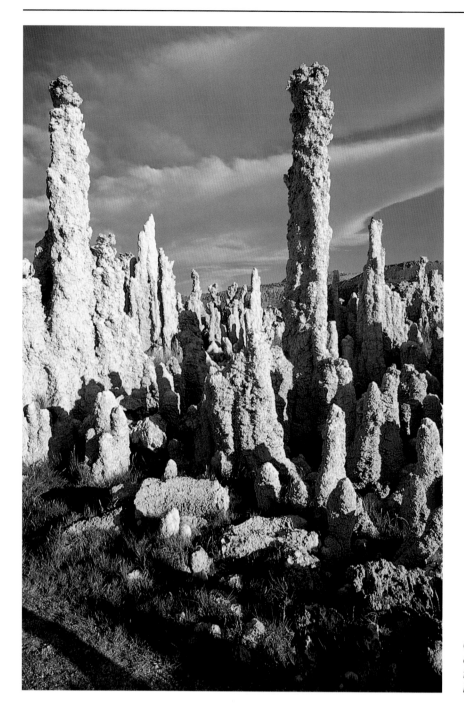

Guidebooks will tell you of unusual geological features of an area before you get there.

phy being through the windows. Holidays of this type show you a lot but leave you little time to appreciate what you are seeing, even less to spend on freelance projects.

If you are thinking about one of these holidays, then, check the itinerary very carefully in advance. The brochure should give you brief details of the route that your journey will take and, most important of all, the mileage you will be doing each day. If the dis-

tance between one destination and the next is anything between 200 and 300 miles or more, then you are going to be on coaches for too much of the time.

For the tourist who doesn't mind continual travelling and who wants to see as much of a country as possible in the shortest possible time, these are great holidays. For the freelance photographer, they can be very frustrating.

Plan your own tour

By far the best kind of holiday for the freelance photographer is the one you plan yourself. That way, you can choose exactly where you want to go, decide how long you want to stay at each place and map out a route that will take you to places that you know will yield the best potential.

Holidays of this type are easy to plan in the UK, but don't be put off the idea of planning your own trip abroad as well. Going into a travel agent and booking a holiday from a brochure isn't the only way of going about things. Planning your own holiday, without the help of a recognised tour operator, can be fun, challenging and a lot more profitable for the freelance.

Some people believe that you can book flights only through travel agents. What nonsense. Every airline has its own reservation service and you can book flights direct with equal ease. When

Does the area you are visiting have something that readily identifies it – like the cable cars in San Francisco? If you investigate the subject before you leave, you'll know what and where to shoot when you arrive.

you do that, it's worth asking for all the options, because some flights are cheaper than others, depending on the time of year and other different circumstances. For example, staying a minimum of a certain number of days or maximum of others can make a difference to the prices of flights. Don't forget to call different airlines as well, since prices might vary from one to the other.

Get a list of hotels from the tourist offices, or from the headquarters of a particular chain. It's easy enough to book them from this country, using credit cards to secure your reservation.

What about car hire? That too can be handled from the UK, although sometimes it's cheaper to deal directly with a hire company, by phone, in the country you are visiting.

Then there's the route you want to take on your tour. We'll be dealing next with researching places before you visit them, and if you have booked a package holiday or tour then there is no harm in doing this research after you have booked. But if you are planning your own tour, you should do this research first. Having done that, you now know the sort of places you want to visit. So it's time to buy a map.

The biggest mistake any British person can make, when looking at a map of another country, is to forget how small the British Isles actually are. You look at a map of, say, France or, worse still, America and equate it with the scale of a map of Britain. It's all too easy to forget that Britain could fit into just one state of America. Places that don't look too far apart on a foreign map might therefore end up being a lot further than you expected.

So check the actual mileage against the scale of the map and make sure you are not being over-ambitious. On good motorway-type roads on the Continent, or on almost any road in America, you'll find it quite easy to cover 100 miles in half a day, and then use the other half of the day for seeing the sights and doing some photography. Drive more than 200 or even 300 miles in a day and you might then need a couple of days at your destination to take full advantage of what's on offer.

For this very reason, it isn't always a good idea to plan out a final route or book all the hotels before you leave. Instead, plan a rough route and book hotels in advance for only the first few nights. Once you get abroad and start to travel, you'll get a better idea of distances and you can then finalise your route and book hotels as you go. It's a good idea, in fact, to stay the first few nights at least in a hotel that is part of one of the major chains. If you do that, you might find they operate a service that books other hotels in the same chain on your behalf.

One extra word of warning when you plan your own holiday abroad in this way. Make sure you take out some insurance. That's the sort of thing that is usually built into the package when you

book through a tour operator, but travelling alone you'll have no cover for your belongings, including valuable camera equipment, or your health – and there's no National Health Service abroad. You need medical help, you have to pay for it. You can book short-term insurance, covering you for just a few weeks, through most insurance brokers. If in doubt, talk to the broker who handles your car insurance.

Business and pleasure

Planning a holiday to incorporate freelance activities this way can be profitable to you, but it might not always be the best of fun for your travelling companions. Few of us holiday alone and it's a good bet that, as well as making your own plans, you will also have to take the wishes of friends or family into account. Unless, of course, you are holidaying with a fellow freelance, but that isn't ideal either, since you will always be on the alert against your companion stealing your ideas – and vice versa! The best bet, then, is to plan a holiday which works for both you and your companions.

Touring holidays are best for the freelance, but don't force children into going along with your ideas. They won't want to spend their whole holiday fortnight in the back of a car. So, if you are touring, allow for more time than you would if you were alone, so that the family can stay for more than a mere half a day in each new place you visit.

One good thing about freelance photography is that the times when non-photographers want to be up and out are the very times that you won't want to be taking pictures. The best light for photography, especially in sunny southern climates, will be early in the morning and later in the afternoon into the early evening. So, if you plan things out in the right way, you can get your work done early, while others are having breakfast or getting ready to go out, or later, when others might want a rest at the end of a long day of sightseeing. The time in between, when you go about the business of having a proper holiday, are probably the very times when the light is wrong for decent photography.

Free trips

Once you have begun to make sales from your holiday pictures, you could find yourself in an ideal position to actually get your holidays paid for with a commission.

It is rare these days for a magazine to commission an unknown freelance, but there are various commercial enterprises that are worth approaching. Hotel groups and tour operators make prime

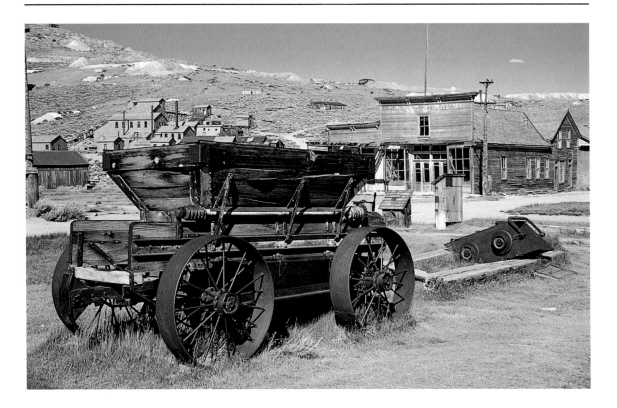

targets. They always need pictures for publicity purposes and they are not beyond offering a free flight and some accommodation for a photographer who will come home with pictures of specific hotels for use in their brochures. They're not going to pay for a complete family holiday for you and yours – but they might pay expenses for just you alone.

How about museums or restored areas like this western town? Would you have known it was near your holiday destination if you hadn't found it first in a guidebook?

The down side of this way of working is that you are unlikely to get paid for the pictures you take for your sponsor, who will consider the free flight and accommodation as payment enough. But there's no reason why you shouldn't use your time away to follow up other freelance leads in exactly the same way as you would on any other holiday.

This isn't the kind of assignment that you can pick up without previous experience, since the companies concerned will want to be certain they are not wasting their money on some snap-happy amateur who can't deliver the goods. But if you use this year's holiday to shoot the kind of pictures they want, then you'll have a portfolio to show around in the hope of getting a commission next year.

That portfolio should contain the sort of pictures which you see in typical travel brochures, in particular pictures of hotels, both inside and out, which could be used in the following year's publications. Other types of picture – landscapes, people and places of interest – they can buy from agencies; pictures of hotels

need to be taken specially for the owners or for the tour operators who book them.

If you want to try your luck for one of these free trips, get your portfolio together and approach the marketing departments of the appropriate companies. You'll find the names and head offices of hotel chains by asking at reception in the hotels you are staying at; addresses of head offices of tour operators can usually be found in their brochures.

Markets and fairs are usually held only on specific days of the week. Find out when to pay your visit in advance.

WHAT TO TAKE

Selling your holiday pictures is all about being prepared, not just for the markets you are aiming at, but equally with the equipment you take. Take too much and the sheer weight you have to carry will ruin your holiday before you get through the first day. Take too little and you'll run the risk of missing a potential sale, simply because the right lens for the job is sitting in a cupboard at home.

It must be said, however, that that doesn't happen very often. The vast majority of saleable holiday pictures can be taken with the very minimum of equipment. Which is how it should be. The motto here is don't take more than you need, but don't stint on the necessities.

35mm SLRs

The obvious workhorse for the majority of freelance holiday pictures is the 35mm single lens reflex. If you are keen enough on photography to want to sell your pictures, you probably already own one.

SLRs come in many different styles these days, from the purely manual to the peak of electronic sophistication. It is not the purpose of this book to discuss the merits of automatic against manual operation, autofocus against manual focus, or any of the computerised wizardry that makes up today's cameras. Suffice to say that there really isn't a bad 35mm SLR on the market, and whatever model you own, it will be fine for freelance holiday photography. The only style to beware of is one that is totally automatic with no option of manual override – a style that is fast disappearing.

However many exposure modes your camera offers, somewhere within its electronic brain there will usually be the option to set shutter speeds and apertures manually, as well as the chance to use both shutter and aperture priority modes. With these, you'll be able to handle all you want and more.

If you are lucky enough to own two cameras of the same make, then always take the second body with you on holiday. This is not a luxury. A second body can be kept loaded with a different film

stock – black and white in one, colour in the other – and, of course, it serves as a useful back-up if something should go wrong with your first body when you're far from home.

35mm compacts

At one time, the serious photographer would have frowned on the very idea of using a compact for freelance work. Today, things are different. The quality of compact camera lenses, the automation that ensures correct exposure and focus, together with the addition in many of dual or zoom lenses, makes a modern compact perfectly suitable for certain types of freelance work. The trick is to recognise its limitations and to work within them.

For the average subject, the automation will be adequate for your needs. But steer clear of subjects that might need manual exposure compensation, which is unavailable on today's compacts.

If you have a dual lens model or one with a zoom, then use the focal length range to its best ability, the way you would use a single lens reflex and a limited range of accessory lenses. If you have a fixed focal length compact, then remember that the lens takes a wider view than you would normally expect from a 35mm SLR – compact lenses are usually fixed at around 38mm, as opposed to the SLR's standard 50mm.

Avoid using the flash on a compact for freelance work. Being built-in, it gives a flat lighting with ugly shadows and the strong possibility of red-eye.

Be prepared for the viewfinder to be less accurate than on an SLR. The field of view is often slightly less than will be seen in the picture you get on film and it won't be parallax corrected, so you'll have difficulty framing close-ups. Also, remember that, unlike an SLR, the view you see through the viewfinder is not the view through the lens. Move in past the minimum focusing distance and the picture will be blurred, even though it remains sharp to your eye in the viewfinder.

A 35mm compact is not an ideal camera for freelancing, but recognise its limitations and a modern compact is perfectly capable of turning out the kind of quality needed for reproduction.

Medium format SLRs

If you own a medium format camera, it might be tempting to leave it behind, simply because of its sheer bulk. Holidays, however, are good places to take pictures that demand larger-than-35mm formats: calendars, greetings cards, travel brochures... they're all areas where you'll increase your chance of success with

medium format.

The best medium format camera is, again, a single lens reflex, offering a choice of lenses and film backs. If you don't own one, but are thinking of buying one, there are three formats to consider, all on 120 or 220 film. The formats are 6x4.5cm, 6x6cm and 6x7cm.

The ideal of these three is the 6x7cm one, but that involves the bulkiest camera. The 6x4.5cm format is one that has gained in popularity in recent years, and this gives you medium format in a smaller, lighter and less expensive camera.

However, perhaps the most popular medium format, with both photographers and editors, is the one that gives the good old, tried and tested 6x6cm square picture. Really, there is no reason why this should hold sway over the 6x4.5cm format, since the majority of 6x6cm pictures end up being cropped to an oblong shape, either upright or horizontal, when they reach the page. But editors and picture buyers are traditionalists by nature. A surprising number of them don't actually understand photography as well as they might. They have been told down the years that if

For precise framing, a single lens reflex is essential. This picture was taken on a medium format model that gives optimum quality as well.

you want quality, you need something larger than 35mm, and the format that they have traditionally trusted is 6x6cm.

A compact isn't ideal for freelancing, but it is capable of capturing pictures like this.

So even though you could probably get exactly the same quality out of a 6x4.5cm format, 6x6cm is what they've come to think they need. And the basic rule of freelancing is give the clients what they want.

If you are contemplating buying a medium format camera for freelance work, then, and if your budget will stand it, skip the 6x4.5cm format and go straight to 6x6cm or 6x7cm.

Medium format TLRs

Speaking of budgets, there is another route into 6x6cm medium format photography that doesn't involve single lens reflexes. If you really are on a tight budget, it's worth considering the old fashioned twin lens reflex. A few of these are still made today, but there are a lot on the second-hand market and you can pick one up in good condition for a fraction of what you would pay for a 35mm SLR.

What you get for your money, in case you are not familiar with twin lens reflexes, is a basic box with two lenses stuck on the front, one above the other. The top lens delivers its image, via a 45 degree mirror, to a hooded ground-glass screen on the top of the camera, the lower one projects its image onto the film. The film in question is 120, taking twelve 6x6cm exposures to a loading.

The cameras are not automatic, however. You have to know how to use a manual camera, setting shutter speeds and apertures by hand. But that's no real problem. If you have an automatic SLR with you, it can be used as an exposure meter, pointing it at the scene you wish to photograph, noting the shutter speed and aperture readout suggested by its automation, then setting those manually on the TLR.

A twin lens reflex is the ideal camera for landscape work, giving a big, bright image on the focusing screen and making composition a real joy. Also because it doesn't use a focal plane shutter, flash can be synchronised at any speed.

Only one current manufacturer (Mamiyaflex), however, offers the advantages of interchangeable lenses. Most have a fixed lens of around 80mm, which is roughly equivalent to a standard 50mm lens on a 35mm camera. Even so, a second-hand TLR, even if the style is rather outdated, makes a worthwhile addition to the kit of the freelance photographer who wants medium format quality on a tight budget.

Lenses

To keep things simple, let's talk about lenses as they apply to 35mm single lens reflexes.

The fact is you don't need a vast armoury of lenses for the kind of pictures that make sales from holidays. You'll be surprised just how many saleable pictures can be taken with no more than the camera's standard lens.

The second most useful lens for this type of work is a wide-angle, the best all-round focal length being 28mm. At this length, you get all the advantages of a wide-angle lens, without any noticeable distortion. Go to wider focal lengths like 24mm, 18mm and wider, and the distortion is more than evident, unless you are paying a small fortune for a rectilinear design of lens. But don't let any of that worry you. Unless you are going for extremely specialised pictures, the widest focal length you'll need is 28mm.

On the other side of the standard focal length, we come into medium and longer tele lenses. Anything up to around 200mm will be useful for the majority of pictures. You can cover that with a few fixed focal length lenses, but your needs should be adequately met by a good quality zoom of around 70-210mm.

Are zooms as good as fixed lenses? The straight answer is no. But, in fact, providing you stick to the reasonably-priced better make of independent lens, or one made by your own camera manufacturer, you're never going to notice the difference with the naked eye – and neither will your picture buyer.

Longer than 200mm, you might find the odd use for a lens of

around 400mm or 500mm; sunsets being a perfect example of the kind of subject than can be enhanced by the longer lenses. If you foresee the use of such long focal lengths, you can often cover yourself by the use of a good quality 2x teleconverter on your shorter tele lens.

If you'd prefer a separate lens in the longer focal lengths, however, go for a mirror lens. They are lighter, smaller and a lot more convenient than a conventional long telephoto. You'll find them predominantly in 500mm focal lengths and their only drawback is that they have fixed apertures – usually f/8 at 500mm.

Filters

With so many special effect filters on today's market, it is tempting to pack your camera bag with them. In fact, although they each give interesting effects in their own way, very few enhance pictures in the way that might be needed in a straightforward freelance context. Unless, of course, you are working for the photographic press, who will buy good quality special effect filter pictures as fast as you can take them.

If that's your aim, and you have your market lined up before you leave, then go ahead and pack as many special effect filters as you can carry. But for the more straightforward job, stick to just a few.

A polariser is a useful filter, providing you use it correctly (See the chapter on Quality Rules). It helps to saturate colour and darken a blue sky.

Ultra violet and skylight filters are often confused. Contrary to what you might have been told, they are not the same and they do not do the same thing. A UV filter takes out ultra violet light, giving a slightly clearer, crisper image, especially on the coast where ultra violet is particularly prominent. A skylight filter takes out the excessive blue that might predominate when you are shooting under a clear blue sky, particularly in shadow areas. Each is a useful filter to keep on your lens at all times, as much for protection as for the effects they offer.

Some graduated filters are useful when used with subtlety. They can tinge a sky with an unusual colour, or darken it, according to which filter you use. A graduated tobacco-coloured filter, for instance, tinges the sky with an orange colour, while leaving the landscape below unchanged. A graduated blue accentuates the blue of the sky. A graduated grey merely darkens the sky without affecting its colour.

Starburst filters are another type that should be used carefully. They turn point sources of light into stars, the sun or street lights in night pictures being prime targets. Keep one with you, but

A semi-fisheye lens of 18mm allows you to shoot super wide-angle interiors.

don't overdo it. The effect can actually spoil a sunset, which is often best rendered, for the freelance market at least, in all its natural glory. Used on a night scene to give extra sparkle to the lights, however, they can be very effective.

Photography these days, amateur and professional, is very much about colour. But the freelance photographer, who will sometimes be aiming at magazines produced on small budgets

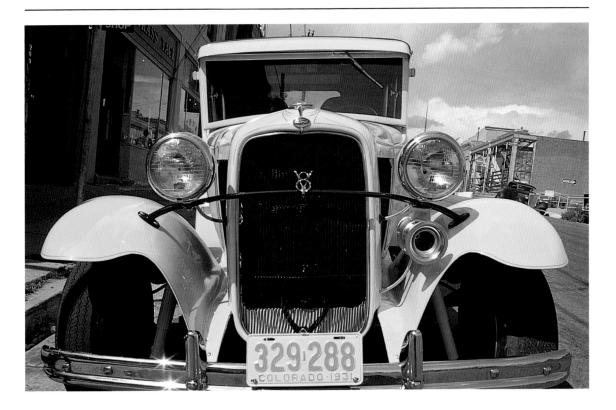

without much capability for colour, will often find it useful to shoot in black and white. The most useful filter in that medium is an orange. It darkens the blue of a sky, making white clouds stand out better by comparison. A yellow filter has a similar, but less dramatic effect. A red filter, on the other hand, accentuates the same effect, sometimes with drama, but often at the expense of realism.

That's something that's always worth remembering in free-lance photography: special effects are all very well in amateur photography and for the photo press, but most freelance markets would prefer the natural approach. Or one that has, at the very least, been fiddled with filters to *look* natural.

A 28mm lens used close to the subject can give a distorted, but nevertheless interesting, perspective on the right kind of subject.

Film

Attitudes to film used for freelance purposes are changing. Time was when it was simple. First and foremost, never shoot colour prints. Use black and white in the form of prints; colour in the form of slides, and make sure it's Kodachrome, because that's the only 35mm slide film that reproduces well. That's the way it was. But not any more.

For a start, let's destroy this myth about Kodachrome being the only acceptable film for freelance purposes. It just isn't so. It's a great film, and Kodachrome 25 – the slowest of the range – is

probably the sharpest colour film around.

But today, with huge advances in film chemistry, there are a lot more contenders that editors and picture buyers are happy to use. Two rules to remember here: go for the slower emulsions and stay with the top names.

By slow, we're talking about nothing higher than ISO 100, and preferably sticking to ISO 50. That is, unless, you have a specialist need, such as demonstrating the abilities of hand-held exposures in low light. That's a feature that could easily interest a photographic magazine. Or you might be taking action that demands the use of high shutter speeds, even in bad light. But outside of those specialist fields, given a low light situation, your picture buyer would prefer you to use a slower film, even if it means sticking the camera on a tripod to allow for long exposure times. At least, think that way as your first option and only use a film faster than ISO 100 if you really have no other choice.

As far as the top names are concerned, keep to those films that are in the higher cost bracket. Don't buy cheap colour films. Some will give you weird colour casts that could easily lose you the chance of a sale.

Likewise, don't use out-dated film. Yes, we all know about the photographer who uses nothing but cheap, ten-year-old film and gets perfect results most of the time. But for every one of those, there's another couple of photographers who have come unstuck. If you are out to sell your pictures, you owe it to yourself not to take chances that might lose you the chance of a sale. It's also your duty to present your client with the best possible quality. And you'll only get that by using top-name film that's bang up to date.

All of which applies to colour reversal films that give you slides or transparencies. As a freelance, that should be your first choice, because it's what the vast majority of freelance markets still want when it comes to colour.

However, times change, and in recent years there has been a growing acceptance among some magazine markets for colour prints, something which was once unheard of. So there is no point in saying that you are never going to sell a colour print – especially since some magazines take them and turn them into rather poor quality black and white images. But the fact remains that however much the market is changing, you'll still stand the best chance of selling colour in the form of transparencies. So that's what you should take on holiday for your freelance work, if not for your normal holiday snapshots.

What about black and white? If, as you know you should, you have analysed your markets in advance, there's a strong chance that you have found a few magazines, and perhaps even poster, greetings card and postcard companies, that use a lot of mono-

chrome reproductions. It is possible for these to be made from colour prints or colour slides, but it isn't always convenient or cost-effective, especially the transformation of slides into black and white reproductions. And if the finished product is to be black and white, nothing reproduces better than a black and white original.

So, if the market you have in mind uses mostly or all monochrome, be prepared and take a few rolls of black and white film with you. There are two types.

The traditional black and white film, silver-based and using the basic chemistry that is as old as photography itself, is probably still the best if you are doing your own darkroom work. Once again, stick to slow and medium-speed films for the best quality. A film like Ilford FP4 Plus at ISO 125 is ideal.

The other type of black and white film is called chromogenic and is exemplified by the Ilford XP1 range. This is not developed in the conventional manner, but in the same way as colour negative films in what's known as the C-41 process. The disadvantage is that it is a lot more difficult – although no way impossible – to process at home. The advantage is that it can be processed in any high street minilab, producing a set of black and white enprints that you can use as proofs. The quality of these enprints, having been treated like colour prints by the minilab process, is not too good. They often show a light green cast. But there will be nothing wrong with the negatives and these can be hand printed in any conventional darkroom in the normal way.

Accessories

A small flashgun is useful for holiday freelancing, although it must be said that you won't be able to use it to take top quality flash pictures in the way that a professional on assignment might. Professionals will take portable studio flash units with them on location, but that isn't really the sort of approach we're talking about here. So pack a small, powerful flashgun, even if your SLR is one of the newer types with built-in flash. Also take a flash extension cable that plugs into the gun at one end and the PC socket or hot shoe of the camera at the other. That will at least allow you to separate the flashgun from the camera, using it at arm's length in a way that can improve the flat look of direct flash lighting. It also gets rid of red-eye.

A tripod is not the most obvious accessory to pack for a holiday, simply because it is so bulky. You certainly don't want to carry one with you everywhere you go on your travels. But if your holiday involves taking your own car, then keep one in the boot and use it whenever possible, even for those landscape shots,

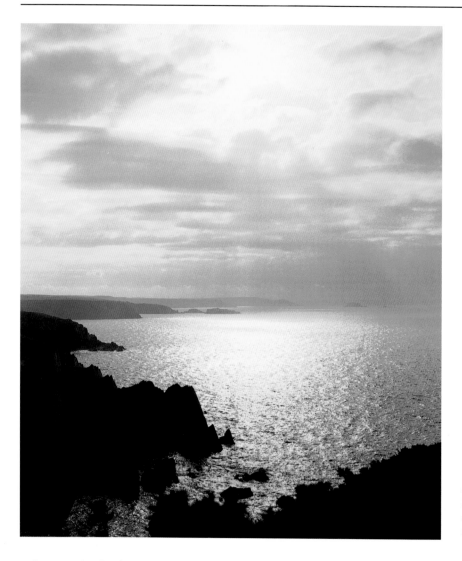

Here a sunset filter has turned a fairly mundane scene into something a bit special.

taken at fairly fast shutter speeds, that you would normally hand hold. Camera-shake is one of the biggest causes of bad quality pictures, and a tripod can help prevent that.

If you can't carry a full-size tripod, consider the use of a small, sturdy table-top model. That will fit a lot more conveniently into a suitcase and can always be stood on top of some other firm support such as a wall or a rock.

Whichever tripod you use, don't forget to also pack a cable release, either of the old manual type or the newer electronic variety. There's no point in fixing your camera firmly to a tripod, only to jog it as you press the shutter button. A cable release will prevent just such a disaster.

If you don't already own a changing bag, then go out and buy one before you leave. A changing bag, if you haven't come across one before, is a like a miniature darkroom. You zip the camera into the bag, then thrust your arms through two light-tight openings so

that you can work inside the bag, safely away from the light. If a film jams in your camera while you're away and you have no way of opening the back without exposing the film to the light, you'll bless the day you bought a changing bag.

The smallest kit

The equipment we've discussed in this chapter will give you the best part of what you need for almost any holiday photograph that you are thinking of selling. If you are taking a car, or if you are a glutton for punishment, you can carry with you everything we've spoken about and more. But if you're on one of those holidays that require you to carry it all with you at all times, then get your kit down to the smallest amount practical.

How little can you take?

Well, every picture in this book was taken on a holiday and, with the exception of just a few specialised subjects, every shot was taken with a 35mm SLR equipped with a 28-85mm zoom lens.

If you're very brave, you'll go off on holiday with no more than that.

HOLIDAY RESEARCH

Successful freelancing relies on accurate research. If you are going about things in the right way, you will have carried out much of that research before you left, looking for the markets you will be shooting for, learning their needs so that you are well prepared when you get to your holiday destination. But there is some research that you can only carry out while you are on holiday. And if you don't do it there, on the spot, you could regret it on your return when you start to actually market your work.

Also, of course, you might find opportunities that you hadn't foreseen arising while you are actually on holiday and, once again, you have to grasp them there and then if you are going to make the most of your holiday photography.

Inflight magazines

The vast majority of magazines that you will be considering as potential markets are national, so you should already have considered the major titles that will be of use to you before you leave. There are, however, some magazines that you won't encounter until you actually set off.

If you are taking a foreign holiday, your research begins on the plane on the way out. All airlines have inflight magazines, sitting in the little pouch on the back of the seat in front of you. Perhaps you've glanced through them before, looking for duty free details, or perhaps reading an article about the place you are about to visit. On your next holiday, look at your inflight magazine, not as a passenger, but as a freelance.

Most of these magazines are put together by quite a small in-house staff, relying on freelances to supply their needs, and most of those needs revolve around illustrated articles about places covered by the airline. Who better to supply the appropriate words and pictures, then, than a freelance photographer going to one of those places?

But do look carefully at the kind of features being used in the magazine. They won't be interested in a straightforward account of a popular holiday destination. Instead, they'll want interesting

articles about offbeat or unusual aspects of the country you are visiting, something that offers the reader new information about the area. So no, you won't sell anything to this market if your entire holiday is about to consist of lying on a stretch of beach in front of a hotel all day. But hire a car when you get to your destination, get off the beaten track, and you might find that picturesque little village that is worth a feature. Or perhaps there is something typically characteristic about the country you are visiting: the windmills in Greece, for example, or maybe an annual carnival that just happens to be planned for the time you are on holiday. Those are the kind of subjects you are most likely to see in these magazines.

Having done your research, don't forget that you are also going to need to know who to contact when you get back. If the airline allows you to take the magazine away, slip it into your hand luggage and take it home with you. If not, then at least make a note of the name of the editor and the address of the editorial offices. You're bound to find both somewhere on the contents page.

Local magazines

Finding a market in local magazines when you are abroad is a difficult business because, unless you are visiting an English-speaking country like America or Australia, the magazines will obviously be in a foreign language. If your knowledge of that language is good enough to be able to analyse and understand their picture requirements the way you would with any British magazine, then all well and good. Do your research, make a note of appropriate addresses, take the magazines home with you and you could find a whole new market opening up for you. But do remember that what seems new and different to you in a foreign country might be completely commonplace to a native.

If the local magazines you are looking at seem to want articles with their pictures, then you really do need to be fluent in the language to supply them. Perhaps, all in all, this is a market to avoid unless you are supremely confident in what you can supply.

A better place to look for local magazines, then, is when you are holidaying at home. Nearly every county in England has its own local magazine. There are also national magazines covering Scotland and Wales exclusively. Few of these will be available outside their own areas, so you should take the opportunity on holiday of buying all you can.

Don't make the mistake, however, of merely buying a local county magazine and stuffing it in your bag to analyse when you get home. Look at the magazine while you're there, in case you

If you're really lucky, your holiday research might even tell you exactly where to stand for the best picture!

see something that needs to be further researched and dealt with on the spot. When you get home it will be too late.

Postcards

Here's a mistake that so many aspiring freelances make. They take loads of pictures on holiday that would be perfect for the postcard

market, get home and can't find out where to send them. True that some postcard companies work on a national basis and are easy enough to find, but others operate only on a local level.

So it's a good idea to look around the local postcard racks, making a note of the names and addresses of the companies publishing the cards. You'll usually find the information you need among the small print on the back of the card.

Look too at the kind of pictures being used. Different companies go for different treatments. Some might want nothing but traditional views, others might want a more creative approach, perhaps using filters or other special effects. The best bet is to simply buy a range of cards to remind you of all the necessary details.

In the chapter on postcards, we discussed how you can produce your own. If you have followed up on that and organised some samples in advance, then now is the time to make some approaches to shops in your holiday area to see if they might be interested in seeing your work. If you don't have any samples yet, at least make contact with a few local shops and ask if they would like to hear from you later in the year when you have some cards of your own to offer. If they show interest, get the name of the shop's manager, the full address of the shop and a phone number. That way, you can make contact from home later in the year when you know what sort of cards you are going to produce. A phone call and some samples in the post to the shop might well land you a sale, which would have been impossible if you hadn't taken time on holiday to do your research.

Local information

On your first day away, buy a good guide book to the location you are visiting. Not one of those big glossy books full of pictures, but one which uses less pictures yet packs in a lot of information about the area.

Look through it carefully for picture and feature ideas. The sanctuary for seals or birds being run by a local charity or perhaps a private individual; the historic windmill or watermill that has been preserved and which is still in good working order; small privately-owned museums of personal collections; the local steam railway preservation society that is giving rides to tourists. These are the sort of things you find in guidebooks, together with opening times, addresses and telephone numbers that will help you organise a plan of campaign.

Most tourist spots have information centres that are also worth visiting to get similar information. They will also have free leaflets that show you the kind of potential you can expect picturewise, together with maps on how to find the places and, once again,

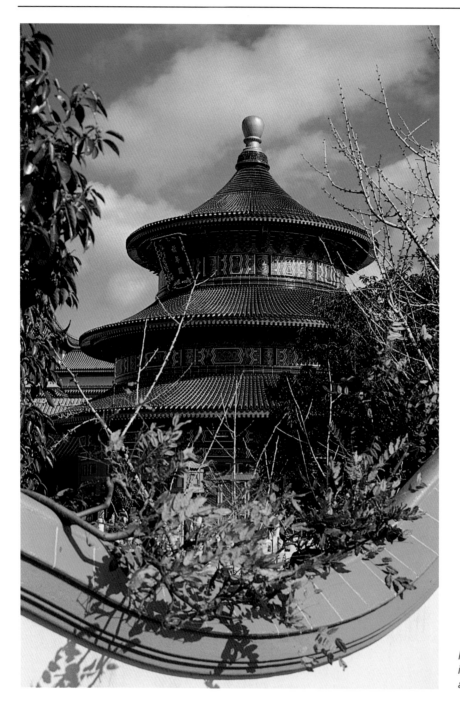

In-flight magazines are interested in articles about tourist areas.

addresses and telephone numbers.

Another early task when you arrive at a holiday destination is to drop into the nearest newsagent and ask what day the local newspaper is published. Buy the paper on its publication day and turn straight to what papers call their entertainment pages. That's where you'll find details of local events happening that particular week: vintage car shows, carnivals, steam rallies, etc – all good

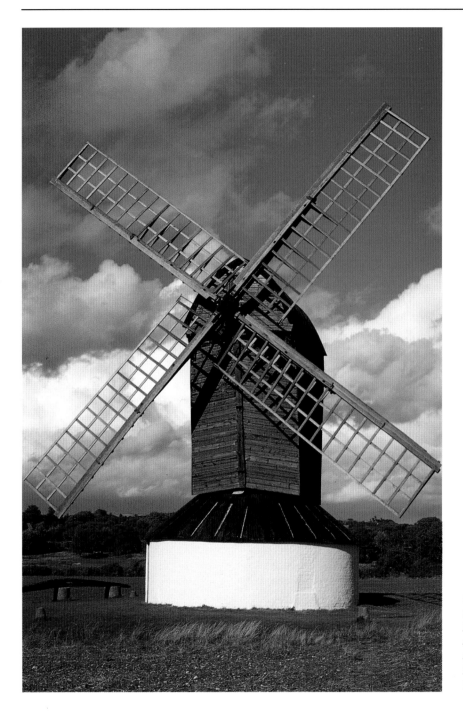

UK holidaymakers can often find subjects for illustrated articles that appeal to county magazines. So look at and buy local magazines while you are away.

fodder for the freelance photographer.

Making contacts

You will notice that, talking about guidebooks and information centres, we've made mention of the importance of gathering phone numbers. That's more important than you might at first

think because it will help you make contact with the people you need to talk to if you are going to succeed in getting the right kind of information and pictures.

Let's look at an example. Let's say your guidebook or information centre has tipped you off that there is a privately-owned toy museum near your holiday destination. It is open to the public as a means of raising funds, so it's a good idea to visit the place and examine its potential as a freelance project. This is the sort of thing that could make an interesting feature for some of the women's magazines, but you won't get your best pictures walking around with all the other tourists.

To do that, you need to make contact with the owner, to ask if you can have a private interview and to perhaps get a few pictures behind the scenes, where the tourists wouldn't normally go. Most organisations of this type are happy to oblige, since they are only too pleased to get the publicity. But they won't want you getting in the way during their busy periods.

So you have two lines of approach. Either telephone and ask if you can make an appointment to come along at a time when they are not too busy or closed to the public, or ask in person on your tourist visit if you can make an appointment to return at a more convenient time. Once that has been agreed, you can interview your subject and then take the kind of pictures that wouldn't otherwise be available from the tourist areas.

When you arrive for your appointment, always conduct the interview first. That way you will have come to know your subject better by the time the photography takes place, and that will help them to relax. Also, the kind of pictures you take are bound to be influenced by facts that you learn during the interview.

Conducting an interview

If you are going to write an article to go with your pictures, or even just add some strong captions, you are going to have to get information. A local guidebook might give you some kind of background, but to make the most of any subject you are going to have to talk to one or more people.

There's nothing difficult or mysterious about conducting an interview, so don't be nervous about it. Or, if you are nervous, try not to show it. Half the battle when interviewing someone you've never met before is to go in full of confidence. Act like an amateur and you'll never get the best from your subject.

If you aim to do a lot of this kind of work, it's a good idea to invest in one of those miniature tape recorders. Otherwise, you can get by simply by using a notebook and pen. You don't have to know shorthand. Most freelance writers find their own shortcuts

to writing down many words and it's quite possible to write fast enough to get the basic information down. It is important, though, to take your time, making sure you get your facts correct and ensuring that your writing isn't so hurried as to make it impossible to read back later. For the beginner a notebook is no bad thing, since you can use the time you need to make notes to think of further questions, rather than leaving uncomfortable silences as you run out of things to say.

Don't go into an interview unprepared. If you've already visited, as a tourist, the place you want to write about and photograph, or if you have read it up in a guidebook, you should already know something about your subject – enough at least to prepare a set of questions in advance.

Let's stick with that toy museum as a typical subject. You will want to know the full name of the person who runs it, how long they have been involved, how it all started, where they get their funds, what happens there on a day-to-day basis, what plans they have for the future, any unusual or funny anecdotes that are worth mentioning.

Questions like these are the sort of thing that you can plan in advance. In fact, write them down in your notebook and use them as a reference as you go through your interview. Don't feel, however, that you have to stick to them religiously. Once you get into a relaxed frame of mind and you get your subject talking, you'll find some questions naturally lead to others and, if you've got the right kind of subject to interview, he or she will talk easily, with little prompting from you.

Conducting the interview, you should always try to keep your subject tactfully on the right course, guiding them back towards the matter in hand if they start rambling about things that have little or nothing to do with why you are there. But if the subject gets talking in the right way, then let them go at their own pace. Don't interrupt unnecessarily. Don't give your own views. Don't disagree with your interviewee, even if they say something that is alien to your own thoughts. You are there only to note down relevant points for your feature.

Make sure that you get answers to all your questions. It's all too easy to ask a question and for the person you are interviewing to go off at a tangent without actually answering it. If that happens, don't be rude about it, merely guide the conversation back to the question you need answering and ask it again.

When you feel the interview has gone on long enough and that you have all the information you need, then bring things to a close. But before you do, ask yourself if you have covered all the main points. Think here of five words: Who, What, How, When and Why. Somewhere along the line, whatever the subject of your

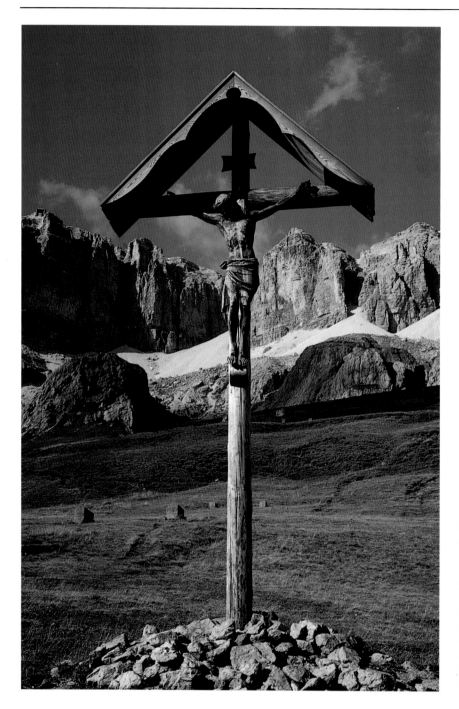

Why has this small shrine been put by the roadside? Are there others in the area? If so, why? Find out and you could have an interesting point to make in an article about the country you are visiting, or perhaps even something that will make an illustrated feature of its own.

interview, you should have asked questions that involve those words...

Who are you?

What are you doing here?

How did it all start?

When did you first get involved?

Why is this project so important to you?

Check not only that the questions have been asked, but that you got satisfactory answers.

Finally, double check that you have the right phone number for your subject, in case you need any further information when you get home.

Taking the pictures

With the interview over, it's time to take your pictures. By now you will have a good idea of what kind of subjects you need. A few general pictures taken around the place will set the scene, but make sure you also include the personal touch.

If, for example, you have been interviewing the owner of our toy museum, then make sure you get a picture of him or her with a particularly unusual or rare toy. Make the pictures as personalised as possible. Don't be afraid to take time in setting up the picture so that you are filling the frame with the subject and making sure that they are smiling for the camera.

Of course the number of pictures you take will depend on the actual subject matter. But try to cover every aspect of the subject from all the angles you have learned about from your interview and, if possible, shoot in both black and white and colour to cover all your markets when you get home. Remember, you won't be able to come back and re-shoot the subject once you return from your trip.

The business side

Enjoy your holiday but, since you are there as a freelance as well as a tourist, don't forget the business side.

Anything that you buy to help you conduct your business is tax deductible. If you buy guidebooks, pay admission to places that might provide pictures or articles, or spend any other money in connection with your freelance activities, don't forget to keep the receipts. You'll be able to charge much of those against tax when you return (for more information on this, see the chapter on Doing The Business).

BASIC TECHNIQUES

An understanding of potential markets is important to every free-lance. But the best market research in the world will come to nothing if you don't actually take your pictures in the right way in the first place. In this chapter, we will examine some basic techniques for the different subjects that you will encounter on your holiday and illustrate the difference between the traditional holiday snap and the kind of holiday picture that will make a sale for you.

Depth of field

An understanding of depth of field is important to many markets such as calendars, greetings cards, postcards and travel brochures. This is because they are markets that demand to see a good record of the chosen subject, rather than the artistic view that might appeal more to you as a creative photographer. Look at postcards and calendars in particular to see what we mean. You rarely see a picture in which any part of the image is out of focus. Sharpness from the nearest foreground object all the way to infinity is an important aspect if you want to sell to these markets, so to make sure you comply with their needs you should have a basic understanding of depth of field.

Let's say you focus your lens at six feet. Although six feet from the camera is now the point at which your picture must be sharpest, there will be an area beyond and in front of that focused point that will still be acceptably sharp. This might mean that sharp focus actually starts at four feet from the camera and finishes at 10 feet. That distance, from four feet to 10 feet, is the depth of field.

When a lot of the picture is in focus, you are said to have a deep depth of field. When focus is more restricted, depth of field is said to be shallow. For the markets we are looking at here, we need to aim continually for the maximum depth of field, and that is controlled by three factors:–

1. The size of the aperture: Small apertures, designated on your lens barrel by the high numbers around f/11, f/16, etc., give a

deep depth of field. Large apertures, designated by low numbers like f/4, f/2.8, etc., give a shallow depth of field.

2. The focal length of the lens: Wide-angle lenses with focal lengths like 35mm, 28mm, 16mm, etc., give a deep depth of field, and the shorter the focal length, the deeper the focus. Telephoto lenses with focal lengths of 100mm+ produce a shallow depth of field, the focus getting shallower as the lens gets longer.

3. The camera-to-subject distance: The closer the camera is to the subject, the shallower the depth of field. The farther you move away from the subject, the greater the depth of field.

So, to make the most of pictures shot for markets like postcards, calendars and greetings cards, you should, first and foremost, use the smallest practical aperture. That might, in turn, mean using a slower-than-normal shutter speed, so a good solid tripod is one important accessory in this kind of photography.

The use of wide-angle lenses also helps extend depth of field and can also enhance a landscape in ways which help make sales. That means around 28mm on a 35mm format, or perhaps 50mm on a medium format.

One other point about depth of field, whatever camera or lens you are using. It is possible to extend it even further by focusing the lens at what's called the hyperfocal point. Here's how.

When the lens is focused at infinity, the nearest point at which the image is still acceptably sharp is known as the hyperfocal point. Refocus the lens on this point and the zone of sharpness is extended now from half this distance all the way to infinity, giving you the absolute maximum depth of field at any given aperture.

If your lens has a depth of field scale, there is one very easy way of doing this. The depth of field scale is identified by a series of numbers, representing lens apertures, starting at the lens's widest aperture, marked out on each side of the focusing mark. For normal use, you simply read this by first focusing the lens accurately on its mark, then reading off the two distances on the lens's focusing scale against the two marks representing the set aperture on the depth of field scale. The zone between those distances is the depth of field that will appear sharp for that focusing distance at that aperture.

Using this scale to set the hyperfocal distance, you simply work the other way around. Line up the infinity setting on the focusing scale, not with the usual mark on the lens barrel, but with the aperture that you are currently using on the depth of field scale. Take a look at the other end of the scale to see what focusing distance is now set at the same aperture marked there and you'll

see that you have focused for maximum depth of field with the aperture in use.

It might sound complicated, but it's not once you have tried it for yourself.

Landscape composition

Because landscapes play such an important role in making sales from your holiday pictures, it's worth learning some of the basic rules of picture composition, many of which will help you turn an otherwise uninteresting picture into a saleable product. Many of these so-called rules are as old as photography itself; older even, because they have been used by visual artists down through the ages. But that doesn't make them any the less pertinent today.

Rule of thirds: Think of your picture divided by two horizontal and two vertical lines, rather like a noughts and crosses grid. Then use those lines to decide where you are going to position the most important elements of your picture.

The horizon in a landscape would be better placed on the upper or lower line, rather than straight across the middle of the picture. A tree or tall building is best placed on one of the left or right lines, rather than in the dead centre.

An object placed on any one of the four intersections of those lines is in a strong position to draw the eye. So use those positions for important aspects of your composition.

Learn to master depth of field to make the most of your pictures. Small apertures and wide lenses give a deep depth of field, wide apertures and long lenses restrict it.

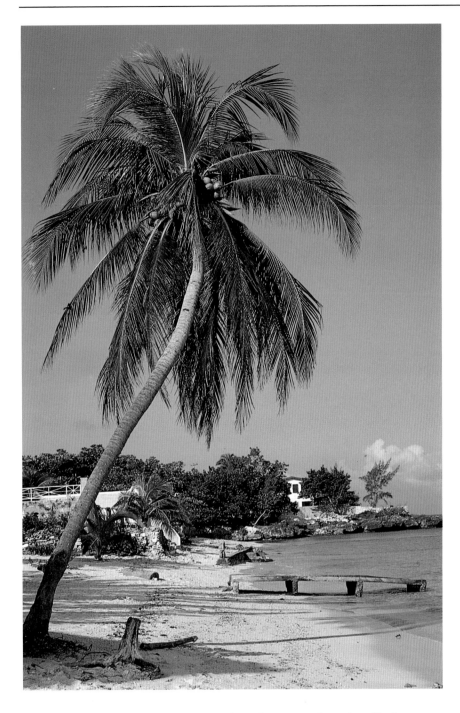

Placing the main subject to one side of the picture, then balancing it with other objects, produces a pleasing composition.

Space to move: Subjects with either actual or implied movement need space to "move into". Some subjects are actually moving when you photograph them. Others, even if they are obviously static, imply movement. A tree, for instance, that has branches leaning more to the left than to the right implies movement to the left of the picture.

Whether the movement is actual or implied, always give the main subject space to move into. So a subject that seems to be

moving from right to left across the picture should be placed on the right, leaving space on the left for it to move into. And vice versa.

Leading the eye: Use different aspects of the picture to lead the eye in a definite direction. A fence, a path, a river, any kind of natural or man-made line can be used to take the eye into the picture. But then, having led the eye from, say, the bottom of the picture to somewhere just off-centre, place or arrange an important part of the subject matter at the end.

A path that leads you into the picture and stops makes an unsatisfying composition. Your eye wonders where to go next. One that leads to a cottage, for example, gives the eye a reason to stop and, having stopped, something to look at. The composition is immediately improved.

Balancing subjects: The way you place subjects in the picture, or the way you position yourself relative to those subjects, also helps to lead the eye and so aid composition. The direction your eye takes makes or breaks the picture.

It's a good idea, then, to arrange your picture so that it has one principal subject, plus other smaller, less important subjects strategically placed in the picture area. Take a traditional landscape, for example: a tree, a cottage and a path. If you can position your camera so that the tree dominates one side of the picture, with the cottage in the distance on the opposite third and a path that travels between them, then you have the basis for traditionally good picture composition. The eye goes first to the tree, travels up its trunk, across the branches, meets the cottage and returns down the path to the tree. That triangular shape drawn by the eye movement is one of the most powerful in good composition.

When you arrange objects in a picture this way, keep in mind that odd numbers of objects usually work better than even numbers – and three works better than most.

The right lines: Pictures usually contain lines. Some dominate, others are more subtle. All contribute to composition.

Horizontal lines are found mostly in landscape photography, with things like hedges across fields, moving towards the horizon, over which a sky is streaked with wide bands of cloud. They give a feeling of peace and tranquillity.

Vertical lines are more dramatic. They give a sense of height, but can also produce a feeling of unrest. Too many, too close to the camera, like a line of trees in the foreground, discourage the viewer from looking past them.

Diagonal lines are dynamic. They give the impression of speed and movement. Used with an action subject, they improve the composition; used with a landscape, they can destroy the feeling of peace that this kind of subject usually demands.

Curved lines, such as the curve of a river or the rounded forms of distant hills, can also imply movement, but in a more graceful, slower way.

Depth and perspective: Stand on top of a hill or cliff-top and look at the scene in front of you. It looks impressive. So why does your picture of the same scene look flat and two-dimensional? Because it has no sense of scale. Once you get past about 30 feet from the camera everything seems to be on the same plane.

The way to combat that problem is to reintroduce a little perspective, by including something in the foreground: a rock, a tree, a gate perhaps. Now your eye compares the foreground with the background and you get a better sense of scale, perspective and a truer interpretation of distance.

Remember all your rules of composition, however. Don't put that foreground object dead centre; place it more to one side. Or perhaps use an open gate to lead the eye into the picture and towards the distance. A closed gate, on the other hand, will block the eye and destroy the delicate balance of composition.

Framing the subject: Another way to introduce foreground interest is by way of a natural frame that outlines the perimeter of your picture, so that you are looking through it into the main scene. Standing in a doorway is one method of framing the subject. Trees with overhanging branches make another.

People in your pictures

If you want to see the kind of "people on holiday" pictures that make sales, look no further than the catalogue for a top picture library. In the Spectrum Colour Library catalogue, for example, around 25 per cent of the pictures are of people on holiday. There is obviously a big market for them, and so this could be a good area for you to exploit. A close look at the pictures, though, shows that the photographers have taken a lot more care than most holiday photographers.

The pictures show single people, couples and families on beaches, children and girls splashing about in the sea, people having picnics, doing exercises, leaping into swimming pools, throwing beachballs and generally having a lot of fun. The age groups depicted are from all generations – children, glamorous girls, young couples, middle-aged couples, even senior citizens – so don't think you can only make sales with people by shooting glamourous subjects. Your family or fellow holidaymakers can all be roped in for a saleable picture.

But now we come to the most important aspect of this type of photography: not one of the kind of pictures we're talking about here was shot without the subject's knowledge. They are not can-

Early evening light from the side enhances the subject when you are shooting buildings.

did pictures. They are all posed, not in the way that a normal holiday snapshot is posed, but in ways that show the people in typical holiday situations with the whole of the picture area utilised to its best. Also, the places in which they have been photographed are largely anonymous. There are no well-known landmarks that identify the pictures as specific locations. Mostly the backgrounds are sand, sea, the blue waters of a swimming pool, or the dramatic sky of a sunset.

From all of this, you can begin to see how to handle people pictures on holiday. First and foremost, don't shoot candidly from too great a distance, showing people with their backs to the camera. Instead, get one or two people involved with what you are doing and ask them to pose for you.

Then think of some ideas that show how much your subjects are enjoying their holiday. You can use the ideas detailed above as a starting point, then add some of your own. Don't forget to use simple accessories, such as Lilos, inflatable toys in swimming pools, food and drink. Most important of all, make sure your subjects look natural and smile a lot. The more they laugh, the better the picture, and the more chance you have of making a sale to markets such as holiday brochures and postcards.

Light on faces is also important here. It's all too easy, when photographing people in bright sun, to allow ugly shadows to fall across their features, so keep a careful eye open for that problem, solving it with fill-in flash or a reflector.

Mountains need something to give them scale. The first picture gives no idea of the height of the mountain. Contrasting the mountain with the town in the second picture works better.

If you shoot people when the sun is directly behind you it will be shining into their eyes, making them squint. Instead, pose them with their backs to the sun and, again, use fill-in flash to lighten the shadow areas. Alternatively, use a reflector to bounce some light back into faces. Portable reflectors are available for this kind of use, but if you haven't brought one on holiday with you, use any large white surface. Borrow a towel from your hotel or, at the very least, use a large sheet of newspaper. You'll be amazed at the difference it makes to your picture.

Children

Children are obvious subjects for pictures that will sell to most markets, including travel brochures, postcards, calendars and women's magazines. Much of what has been said about photographing people in general equally applies to children, but it's wise to keep a few extra thoughts in mind with the younger generation.

Make sure you shoot them when they are involved in some kind of activity, rather than in the typical "smile for the camera" holiday pose. Playing on the beach or in playgrounds, horse riding, getting involved with water sports, leaping out of the sea or a swimming pool – these are all good starting points.

Children are naturals. They rarely show the self-consciousness that adults exhibit when you ask them to pose for you – and make no mistake, you should still be thinking in terms of posing your subjects rather than shooting them candidly. Photograph a child playing in the sand without any thought of posing, and there's a

good chance that you'll end up with shot of the top of a head. Pose the same child as you get down to his or her level and you'll get a happy, smiling face. If you were an editor, which one would you buy?

One problem with photographing children, however, is that they have a low boredom threshold. What starts off as a game quickly becomes a bore and they want to be off doing something else. So when you are planning a shoot with young subjects, get as much sorted out in your mind before you start: poses, accessories, lighting, etc. Introduce your model at the last minute, keep them happy with a few jokes and don't shoot beyond the point when you begin to see boredom creeping on. Bored subjects produce boring pictures.

Better buildings

Picturesque buildings, from rustic cottages to ultra-modern sky-scrapers, can be good sellers if you treat them the right way.

The first point to remember when you photograph any building is perhaps the most obvious of all: you can't move it. With people, you can turn them round until you have them in the best light. With buildings, you have to wait until the light hits them in the best way. It might sound obvious, but until you really look at the way light is falling on a building it's easy to miss the pitfalls, because what the eye thinks it sees and what the camera actually records can often be two different things.

The main problem is shadow. If the sun is shining on your subject from the side or from behind, then the part of the building facing you will fall into shadow. That doesn't look particularly disagreeable to the eye, but the camera will record the scene as dull and flat at best. At worst, automatic exposure might adjust for the scene around you, which is better lit than the shadowed building, and the important part of your subject will end up under-exposed and lacking in detail.

So really look at where the light is coming from, and if it isn't right, come back at a different time of day. The very best light for this kind of subject is when the sun is shining obliquely on to the face of the building. It illuminates it to its best effect and the angled lighting brings out the relief in brickwork and stonework.

Mountains

Mountain scenes can be impressive, but do remember that mountains can also be dangerous. Don't attempt to climb unless you are experienced. Remember too that these higher areas can be colder than at sea level, so if you are planning a trip into the mountains,

dress accordingly, and don't forget that extra cold climates can lead to batteries failing. Carry a spare in the warmth of a pocket.

Mountainous areas are often rich in ultra violet light, and while you might not notice this with your eyes, the film will record too much UV as a haze, leading to a loss in definition in your pictures. A good UV filter is a must for this type of photography.

When you are shooting from a high point, out over the landscape below, think about the rules of composition we have already discussed. A flat plain stretching for miles might take your breath away when you're there, but it can be very boring in a picture unless you contrast it with some kind of foreground interest to give the picture depth and a sense of scale.

Beaches and seascapes

Those last points also apply when you photograph the sea. Stand on the beach with the waves pounding in your ears and you'll feel an excitement that can rarely be translated on to film. In the picture, all you see is a flat expanse of water. So, once again, think about composition, using rocks and the like as foreground interest, perhaps contrasting them compositionally with a boat further out to sea.

On the beach, be very careful with light and exposure. This is one subject that never photographs well in the flat light of midday. Always shoot beach subjects in the early morning or late afternoon, when the low sun gives extra texture to the sand.

Also beware of the sun's reflection from the sand fooling your meter. If you are including a lot of sunlit sand in your picture its brightness could easily lead to underexposure. It's best, then, to meter off a more neutral object such as a coloured beach towel or umbrella, even the palm of your own hand, and then set this reading manually rather than relying totally on the camera's automation.

Skies

Look through the files of most photo libraries which handle the kind of subjects that we're dealing with here and you'll undoubtedly find a whole section on nothing but the sky. It's a subject that changes all the time and it can be a good seller if you handle it in the right way.

Skies are usually best shot against the sun, or at right angles to it, rather than with the sun at your back. Expose for the sky itself, allowing the landscape below to fall into shadow or silhouette. Shoot some pictures that use the landscape as a thin strip across

Take care with exposure on beaches. All that light-coloured sand and water reflecting the sky could seriously influence the meter, leading to under-exposure.

the bottom of the picture, then tilt your camera and shoot nothing but the sky itself. It helps to give your editor or picture buyer a choice of approach, depending on the use to which they are planning to put your pictures.

Shoot straight and with filters. The polariser is your most obvious filter here, providing you remember the right way to use it. A polariser darkens the blue of a sky dramatically; it does not work on a dull or overcast sky. Neither does a polariser give its best when shooting towards or directly away from the sun. For maximum effect, fit the polariser to an SLR, shoot at right angles to the sun, and rotate the filter until the best result is seen in the viewfinder. Automatic exposure systems will cope with the extra exposure needed for the darkening effect.

Other special effect filters that are useful with this subject include graduated types, starbursts, diffractors and subtle coloured ones, such as those sold as "sunset filters". When you do use a filter on a sky, however, always shoot another picture without. That's because while one picture buyer might like the way it enhances the subject, another might be a purist who wants nothing but the straight shot – or perhaps the slightly tampered-with

straight shot that is the result of using a polariser. In any case, shooting the same subject both through different filters and without is particularly useful for those wanting to sell technique pictures to photographic magazines.

The best time of year to photograph skies is spring and autumn. Since the summer months tend to be cloudless, the presence of the few white clouds that you're more like to see at other times can add tremendously to your sales potential.

Rainbows

Shot in the right way, this is a subject that can be a good seller, simply because you have to be very lucky to be in the right place at the right time. Hence, there aren't too many good rainbow pictures about.

Rainbows occur when the sun shines, usually from a fairly low angle early or late in the day, at the same time as rain is falling. Because they occur in the sky opposite the sun, they are very often highlighted against the dark clouds that are producing the rain.

The best place to photograph them is across open countryside, because all too often they disappear behind buildings, spoiling the effect.

With a standard lens, you will record little more than a third of

Seascapes don't always have to be shot in daylight. This shot, taken at sunrise, has been a good seller over the years.

the total arc; the only way to capture the full arc is with an extra wide-angle lens of around 18mm.

Running water

Water can be photographed in two different ways, and each is effective. Use a fast shutter speed of 1/500 or 1/1000 second and you can freeze the movement so that every drop looks like a jewel or piece of glass.

Use slow speeds of 1/15 second or slower and the water blurs to look like cotton-wool. You can actually take this technique as far as you like, depending on the prevailing lighting conditions and the minimum aperture of your lens (since the slower the shutter speed, the smaller the aperture needed to render correct exposure). Add neutral density filters, which cut down light without colouring it, and you might even be able to run your exposures into minutes to give an extremely surreal effect.

Neither of these effects actually records water the way we see it with the naked eye. So for the most natural effect, go for a shutter speed of around 1/250 second.

Snow

No one is saying that every holiday you take will be at the height of summer, or at traditional sun, sand and sea locations. There's profit to be made too from winter holidays, so a few thoughts on how to get better pictures in the snow won't go amiss.

Snow pictures are best taken when the sun shines, just after a fresh fall of snow. Old, slushy snow, shot under leaden grey skies, stands very little chance of selling. Back-lighting and strong side-lighting gives the best effects.

Everything already stated about the dangers of exposure with sand equally applies to shooting in the snow, so take readings from surfaces that do not include large expanses of white. Generally speaking, you need to open up around two stops on the exposure you would get if you metered directly off a fresh fall of white, sunlit snow.

Under a blue sky, snow may take on a slight blue cast in the open and look definitely blue in shadow areas. You can compensate for that to a certain extent by the use of warm-up filters such as the 81A and 81B types. And while we're on the subject of filters, this is not a good place to use a polarising filter. It still works on the sky of course, but because polarising filters work by reducing reflections, they can easily destroy the lovely sparkle that sun creates on snow.

Night photography

Composing pictures at night is not so very different from shooting in daylight. The big difference, of course, is exposure. For the best night shots, you should stick to your normal medium-speed film, mounting the camera on a tripod to hold it steady during extra long exposures.

At best, exposure for night photography is a compromise. Too little and you get highlight detail, usually represented by actual lights, surrounded by too-dark shadow areas. Too much exposure and you get detail in the shadows, but the highlights will be severely burnt out. To get the best results, then, you have to find a happy medium.

Don't trust automatic metering, which can easily be fooled, either by the bright lights or the jet-black areas. Instead, take a reading off something that the lights are actually illuminating: the side of a floodlit building, for example, or even the pavement of a busy city street.

Once you have an exposure reading taken this way, set it manually on the camera and then take several shots, bracketing exposures by one or two stops more and less than your original setting.

Sunsets

Finally we come to what must surely be one of the most popular subjects for holiday photography. But beware. It must be said that editors and picture buyers see an awful lot of pictures of sunsets. They do sell, but in order to help yours attain success, they have to be a little more unusual or dramatic than the usual straightforward type of sunset snap.

Summer, when we expect to see the sun the most, is not the best time for sunset photography. Autumn is good because it produces more dramatic skies and cloud formations, but don't neglect the winter either. A sunset taken on a winter holiday can be the most dramatic of all.

For the best results, don't just shoot the sun and sky alone. Find interesting foreground subjects – trees, gates, fences, rocks – to contrast with the sunset beyond. Adjust your exposure for the sky and the foreground will be underexposed to give a dramatic silhouette effect against the colour of the sunset.

Shoot across water too, reflecting the colours of the sky and so enhancing the picture.

Unless you are shooting a sunset with an extremely dramatic sky, in which the main aspect is the clouds rather than the sun itself, you should always shoot a sunset with the longest lens possible. The image of the sun on a 35mm negative or slide will

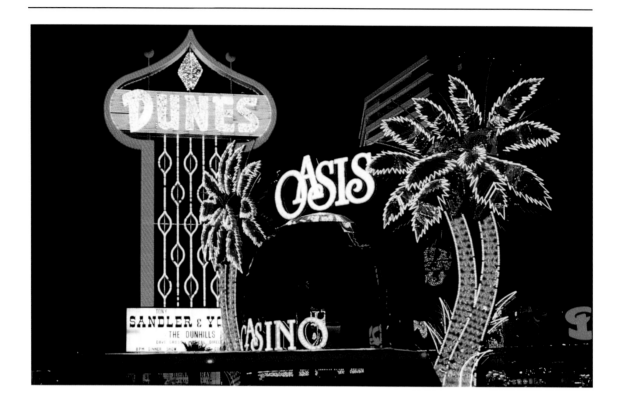

record at 1mm for every 100mm of focal length. So, with a standard 50mm lens, the sun will look only about 0.5mm across on the 35mm frame. But, by the same token, a 200mm lens will record the sun 2mm across, which is the point at which it begins to look interesting in a photograph. Longer lenses still of 400mm, 500mm or even 1,000mm, produce exaggerated, but very effective results.

Sunset photography is another area when you should not trust automatic metering. Even the most sophisticated can be fooled by the super-brightness of that small object that is usually dead centre in the viewfinder, and therefore influencing the metering more than anything else.

Generally, then, you need more exposure than the meter might indicate and, for that, meter for the sky beside the sun, aiming the camera so that the sun is towards the edge of viewfinder frame for metering purposes. Then set that reading manually, recompose and shoot.

Finally, don't pack up and go home as soon as the sun drops below the horizon. Wait around for anything up to 45 minutes in summer and you'll see the sky gradually changing. The transition from reds and oranges on the horizon, through purple to blue in the sky above, makes a great picture that many photographers miss – and those are the pictures which sell the most.

Night photography needs a tripod or a super-fast film. Best quality comes from shooting with medium-speed film, while supporting the camera for a longer than normal exposure.

QUALITY RULES

Take a picture of an aeroplane crashing in the middle of London and you needn't worry too much about whether or not the image is as sharp as it might be, the direction of the light or even accurate exposure. Providing the lens cap was off at the moment you pressed the shutter release, you've got a sale. And that's the only time you're going to get away with slapdash technique.

In this age of electronic cameras, many of the old problems of photographic technique have been taken care of on your behalf. The vast majority of cameras will turn out correct exposure the best part of the time, while autofocus has done a lot to cure the problem of blurred images. But just because you have a fully-automatic camera, don't assume that it will automatically give you top quality every single time. A lot of what goes into getting the best quality is still very much down to you. The time of day you shoot, the way you handle automatic exposure, the direction of the light – they all contribute to better photographic quality. And the better the quality, the more chance you have of making sales.

Let's take a look at some of the ways that you can ensure top quality.

Early morning or late afternoon light gives the best quality for most holiday subjects.

Keep it clean

Specks of dust or – worse still – fingerprints on the elements of your lens might not record on the picture as such, but they will affect its overall contrast, and that leads to a loss of definition

So check out your lens, the back element as well as the front, because it's all too easy to leave a fingerprint behind when you change lenses, without even knowing it. Clean the elements with a good quality lens tissue and *carefully* use cotton-wool buds to reach into the corners. Check out the inside of the lens cap as well, so that dirt is not transferred from there to the lens when you replace the cap.

Check for foreign matter inside the camera body too, especially if you are holidaying by the sea. Even the smallest speck of sand finding its way on to the pressure plate inside the camera back can lead to nasty scratches on the film. When you are on location like this, it's a good idea to check your equipment thoroughly, dusting it all out with a soft blower brush, every night of your holiday.

Quality of light

The most automatic of cameras can't tell you the best time of day to shoot. That comes only with experience. The hard fact is that the time of day when most of us are out and about on holiday is probably the worst time to shoot, especially true if you are going south for the sun. We're talking here about the time around the middle of the day in summer, between perhaps eleven in the morning and four in the afternoon.

These are times when the sun is high in the sky, casting short, stubby shadows. The light is flat. It destroys contrast. Even the most opposite of colours can seem to blend into a stodgy neutral tone under this unattractive light. What's more, if you are shooting people, their eye sockets will be thrown into deep shadow. The best time of day to shoot is early morning, or late afternoon into early evening.

This, then, is one of the big problems of shooting freelance pictures on holiday, especially if hotels and families are tying you down to a timetable. By the time you've had your breakfast, it's too late, and by the time the light is right again, you're probably thinking about getting changed for your evening meal.

On the other hand, that very fact can give you a strong advantage if you have planned the right kind of holiday. It means you can be out taking pictures before the rest of the family is up and about or having breakfast, or later when they are having the evening meal, thus leaving you the most unattractive times of the

day, photographically speaking, to enjoy the holiday itself. It's a perfect situation – if you don't die of starvation!

Early or late in the day, the sun is lower in the sky. This has two direct effects on the way it illuminates various subjects and records on film. First, because the colour of the sun tends more and more towards the red end of the spectrum as it sinks lower in the western sky, the actual colour of the light is different. It gives a warm, attractive glow to everything, not immediately noticeable with the naked eye, but easily seen and recorded by all daylight-balanced colour films.

Being lower in the sky, the light also falls differently across the subject, giving a very different effect to the light of noon. Which brings us to...

Direction of light

Here's a warning. It is very easy to take the direction of light for granted. The human eye is a wonderful, but deceiving, thing. Left to its own devices, it will ignore what it doesn't want to see.

Take the case of a building, with the sun falling from behind or strongly to one side so that the front is in shadow. You probably don't even notice the fact. But point a camera at the building and you'll see a lot of shadow, resulting in lost detail, contrasting with a brightly lit landscape, maybe around and behind the building. If that building was the whole point of your picture, you've lost the opportunity to get the best quality – and, with it, you've probably lost the chance of a sale as well.

So that's the first thing to learn about the direction of light. Don't take it for granted. Look at it. Note which way the sun is shining, which parts of your subject are properly lit and which parts are in heavy shadow. Remember that during the course of the day the sun appears to move across the southern sky from east to west – that's left to right if you're looking south. If the light isn't right first thing in the morning, there's a good chance it will be better later in the afternoon, and vice versa.

The great thing about being on holiday when you are faced with this sort of situation is the fact that you probably have time to come back at another time. So don't always think you have to shoot a particular subject as soon as you see it. If the light isn't right when you first see something of interest, estimate what time of the day it will be better and return at a leter date.

In fact, it's not a bad idea to do this in the middle of the day as well. Use the worst time for photography to reconnoitre your subjects, deciding when you will return to shoot. In such circumstances it helps to carry a small compass to help you work out when the light will be best. You can buy one at any good camping

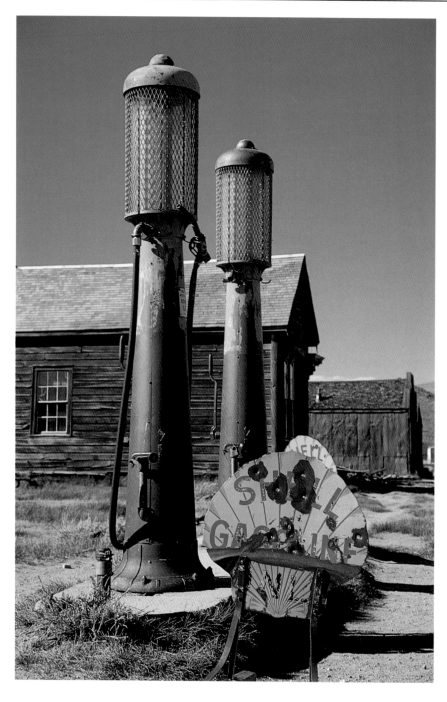

Side lighting helps to reveal texture.

shop.

Once you have your time of day sorted out, then use the direction of the light to improve the look of your subject. There are four basic light directions worth considering: frontal, oblique, side and back. Here's what each does.

Frontal lighting illuminates the subject well, but makes it look flat and two-dimensional.

Oblique lighting, when the sun falls from an angle of around

30-45 degrees on the subject, adds relief. Stone and brickwork records much more attractively. Long shadows, sloping diagonally away from the subject, can be used to aid composition.

Side lighting, with the sun falling at ninety degrees, produces sharp contrasts between the sunlit side of the subject and the immediately adjacent one that now falls into shadow. That can ruin some pictures, for all the reasons already mentioned above, but it can also be used to dramatic effect on other subjects. Again, shadows become part of the composition.

Back lighting is another effect that can make or break a picture. You wouldn't use it, for example, on a shot of a picturesque old church, in which sunlight from the rear would leave the front of the building in shadow. But use it on more translucent subjects like autumnal leaves and it's a different matter entirely. Backlighting shining through leaves, petals or any other translucent objects makes them glow as if with an inner light. It's also useful for people shots, drawing a halo of light around their hair.

Exposure

Who needs to worry about exposure, when it's all automated these days? The answer to that is simple: you do, if you want to get the best quality from your pictures. Certainly, if you are taking fairly straightforward pictures of conventionally-lit subjects, there's a 99 per cent chance of the automation getting it right on your behalf. But the photographer who takes the best pictures is all too often working in that odd one per cent area, simply because he or she is trying to get something a little out of the ordinary, and that's when the meter is sometimes fooled.

Accurate exposure is important on a subject like this to get the best quality. If the camera's automation had been influenced by the dark foreground, the quality of light on the mountains would have been lost.

What doesn't help is that for certain types of subject there really is no such thing as perfect exposure – it all depends on the kind of effect you are after. And, while the latest cameras are clever, they still haven't learnt to read minds.

Confused? Look. Take that good, solid holiday standby – the traditional sunset. Now think about the different ways you can get that subject on to film:

1. With the sun glowing menacingly from a dark, brooding sky.

2. With the cloud formations recording in a riot of colour.

3. With a foreground object silhouetted jet black against the sun.

4. With more detail in a lighter foreground.

If you simply arrive at the scene, point your camera at the subject and leave it all to the automation, you might get one of those effects, but it probably won't be the one you wanted. To get the picture you want exactly right you must expose for the subject, and that means four different exposures for those four different approaches above. And to do that, you must switch the camera to manual and take it as close as possible to your subject, or at least point it in a direction that allows your principal subject to dominate the viewfinder. Having read the exposure indicated by the camera's meter, you can then set that manually and return to your chosen picture composition, ignoring what the meter now tries to tell you is correct.

So to get those four effects mentioned above, you would have to expose as follows:

1. Expose for the sun, allowing everything else to fall into under-exposure. (This in all probability is what your automatic meter will do for you.)

2. Expose for the sky beside the sun.

3. Expose for the sky, allowing the foreground to under expose.

4. Expose for the foreground, content to let the sky and sun over expose and so record lighter in the picture.

In talking about sunsets here we are talking about extremes, since the subject deals with strong sunlight coming straight towards the camera. That is something you should always take care with if you want to avoid incorrect exposure. In fact, on *any* back-lit subject, even a portrait with a halo of back-lit hair, you should always meter by taking a reading from close to the face and, if in any doubt, open up by one-and-a-half to two stops.

But, for the best quality in any picture, you should always decide on which part is the most important and try to meter for that, by taking the camera right up to the subject whenever possible, by using the spot metering mode if your camera has one or, if both those techniques are impossible, by simply taking an intelligent guess, together with a little bracketing (shooting at what you

have decided is the correct exposure, plus separate pictures taken at one or two stops more and one or two stops less).

Yes, modern meters might make much of this advice redundant, but never take them for granted. Also remember that the true freelance, shooting in colour, should be using colour reversal or transparency film, and its latitude to incorrect exposure is nowhere near as great as the colour print film you used to use when you were just a holiday snapshooter.

Avoiding flare

Flare happens when light bounces about inside your lens rather than taking a direct route through the elements to the film. It happens with some lenses when you shoot directly into the light. Older or cheap zoom lenses are particularly prone to flare. It also happens when a lens is dirty, the dust or marks scattering the light as it hits the front element.

The problem can also cause mysterious lines or patterns, shaped from the aperture of your lens, spreading across the picture in a line, usually from the sun.

To get round the problem and so get better colour saturation, first and foremost use the best possible lens at all times, if possible using a fixed focal length rather than a zoom. Secondly, use a good, deep lens hood to keep direct light from falling on the lens. Third, try to position yourself in the best position to avoid flare. Using a single lens reflex, you'll see the contrast falling off in the viewfinder when the lens is flaring. You'll also see those lines of aperture-shaped marks appearing. When you see either of those problems approaching, move around and change the camera position until it disappears.

The picture that contains the least amount of flare will be the one with the most colour saturation, the best quality and the highest chance of making a sale.

Polarise it

Colour saturation and therefore picture quality diminishes with reflections – and that doesn't just mean reflections in glass, polished metal or water. There are reflections too in any wet object, even in the air itself which is full of water particles. Kill the reflections and you get better colour saturation. The best way to do that is with a polarising filter. Used in the right way, the filter cuts out most reflections and so increases colour saturation. It is most noticeable on landscapes, particularly affecting blue skies. Contrary to the belief of some, it has no effect on a grey sky.

To use a polarising filter correctly, shoot at an angle to the subject: water, a glass-fronted building, or whatever. With landscapes, to give more saturation to the blue of the sky, shoot at right angles to the sun, never directly towards it or away from it.

Place the filter on the lens of an SLR and rotate it as you look through the viewfinder, watching the way the colours change as you do so. There will come a point at which the effect is at its maximum, and that's the point to shoot. Through-the-lens metering will automatically compensate for the extra exposure needed with a polarising filter.

When shooting into the sun, avoid flare. The problem has spoilt the first picture (left), but a good deep lens hood has helped prevent it with the second.

Camera shake

One of the biggest reasons for bad quality is camera shake. The best way to get round that is to use a tripod whenever possible. Yes, they are heavy, cumbersome devices. And no, none of us really wants to carry one on holiday. But watch the professionals at work and you'll nearly always see the camera on a tripod. Failing that, rest the camera on any conveniently firm surface. Or at least try to support yourself against a firm surface as you shoot.

Also, when shooting with a hand-held camera, always work at the highest practical shutter speed – never below 1/125 second with a standard lens, and preferably at 1/250 second. If you switch to longer lenses, switch also to faster shutter speeds, remembering that the 1/125 second that was adequate with a 50mm lens will inevitably show shake with a 500mm lens. When in doubt, use these as your very minimum speeds, and preferably go up one or two speeds whenever possible: 1/250 second for a 200mm lens, 1/500 second for a 500mm and 1/1000 second for a 1000mm.

Accurate focusing

In this age of autofocus lenses, there should be no real need to talk about subject sharpness. But, just as with automatic metering, automatic focusing is not totally infallible.

If you are using a manual focus camera and have faith in your focusing abilities, then you have no excuse for blurred pictures. But autofocus can sometimes lead you astray, especially if you take it for granted. Remember, for example, that in most instances the system is automatically focusing on subjects that fall within that little square outlined in the centre of your viewfinder. If your picture requires a sharp subject to one side of the picture area, then you need to autofocus on that first by directing your camera so that the required subject falls within the autofocus indicator. That done, you must then use the camera's focus lock control to retain the distance that has been set on your lens before recomposing and shooting with the subject off-centre.

Also remember that there are certain circumstances in which autofocus can let you down. These might include large areas of your subject with no real contrast in them; bars or fences, when you must ensure that the automation is focusing *between* the bars of a cage or the slats of a fence, not *on* them; and glass, which can cause problems if you are photographing a scene outside a window or inside a glass enclosure – certain autofocus systems might try to focus on the glass itself instead of the subject beyond.

In any case, you should always try to keep maximum sharpness throughout your pictures when you are shooting for general publication. While an artistic approach to photography might call for the use of differential focus, the majority of freelance pictures require a far more straightforward record of the subject – and that means sharpness as far as the eye can see. What we're talking about in technical terms, then, is the best possible depth of field, as discussed in the previous chapter.

As we have seen, small apertures generate a deep depth of field, wide apertures reduce it, and for most freelance pictures,

needing as much in focus as possible, you should always use the smallest practical aperture. But here's a warning. Smaller apertures mean slower shutter speeds, and we've already covered the problems there. The answer is to go for the best compromise: something around 1/125 second at f/11 or the equivalent 1/250 second at f/8 is fine for a slow-to-medium speed film in good sunlight, and gives you a fast enough speed with a small enough aperture when using a standard lens.

Long focus or telephoto lenses reduce depth of field, wide-angle lenses increase it. So to keep as much in focus as possible, stick to standard or wide lenses whenever possible. If the subject matter demands a longer lens, then remember the problem and always shoot at the smallest practical aperture, once again remembering the problem with shutter speeds which, this time, have to be associated with long lenses. Again a very good reason for always carrying a tripod!

As you get closer to the subject, the depth of field becomes shallower. If you are shooting close-ups you can get away with a sharp subject against a blurred background. But with a subject like a landscape, you should avoid allowing very close objects to creep into the corners of your picture. This shouldn't, however, preclude you from including things like gates, tree branches, or the like as part of the foreground interest to improve composition, because once those objects get to be a decent distance from the lens, the problem is reduced. The problems arise when objects are around three feet (about one metre) away.

Into the darkroom

Everything we've discussed so far applies to shooting the pictures. But quality doesn't end there. For freelances shooting black and white – and there are still a lot of markets ready and waiting for monochrome – the pursuit of quality continues into the darkroom. Here are a ten tips to make sure your darkroom technique is up to scratch:

1. Check that your darkroom really is light-tight and that the safe-lamp is the right colour and at the right distance from your developing dishes.
2. Keep the darkroom as dust free as possible. Don't hang negs up to dry in a dusty atmosphere.
3. Brush the neg over with a soft-haired blower brush before printing.
4. For 35mm, always use a glassless negative carrier. If you are shooting on larger formats and have to use a glass carrier, make certain it is spotlessly clean.

5. Always use the best quality enlarging lens you can afford. There's no point in taking pictures through a top-class camera lens, then printing them through an inferior bundle of optics.

6. Use the right grade of paper for the negative, or choose the right filtration when using polycontrast papers.

7. Refine your actual printing techniques. Never take the print out of the developer too early. If it appears to be ready in less than the required time, you've probably exposed it too long under the enlarger and the contrast will be wrong. Stick to the recommended time in the developer and adjust matters with your timing under the enlarger.

8. Do not expose the print at the enlarger lens's widest aperture. By all means focus at the widest setting, but then close down a couple of stops for exposure.

9. Don't judge print quality solely by the light of the safelamp. Evaluate it under white light.

10. Don't be afraid to waste printing paper. If you think there is room for improvement in any print, then throw it away and start again.

Always remember, whether you are in the darkroom or in the field, that picture quality is of paramount importance in any branch of freelance photography. A top quality, well-presented set of prints or slides spells professionalism to any editor or picture buyer even before he or she looks at the actual content. Bad quality immediately ranks you as an amateur. And in this business, even if you are an amateur in theory, you still have to compete with the professionals in practice.

ADDING WORDS

Many of the markets that we've talked about in this book require only pictures. These are markets like calendars, greetings cards, travel brochures and picture libraries. But we've also talked about interviewing people, gathering facts and using your pictures as illustrations to written articles – and for that application we are looking at one of the biggest markets open to you, in the shape of magazines.

Some magazines, it's true, will buy pictures alone. Titles like *This England*, for example, use pictures of the English countryside, easily taken on holidays. These they print in the opening pages of the magazine, together with little more than a caption or sometimes a few lines of prose or poetry that are added by the editorial staff. All you have to do is supply the pictures with a caption, describing where it was taken. Markets like this are very useful to the holiday photographer, but the vast majority of magazines look more towards using words and pictures together.

Sometimes they will accept your pictures alone, put them on file and use them later, tied in with staff-written articles or those from freelance writers that don't have pictures of their own. When you think seriously about this way of working, however, you can see that it is a little hit and miss. In order to have exactly the right picture to go with any staff or freelance written article, they need a very big file, containing many pictures. The more pictures they have in that file, the less your chances are of making a sale.

A much better way of getting your pictures used with words, then, is to write them yourself. That might seem a little daunting at first but, once you make a start, you'll be amazed how easy it can be.

Simple caption writing

At the very least, you have to identify your pictures with captions, even if you are merely sending them to a magazine that accepts pictures alone or if they are being submitted for file use. There are two ways of doing this, depending on how much information you need to get across.

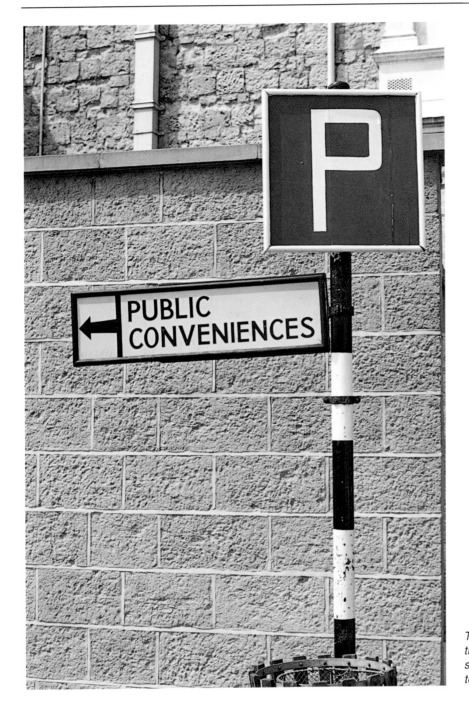

The kind of novelty shot that demands only a short, amusing caption to make it sell.

If you are submitting black and white prints, simply type or write clearly on a strip of paper and attach that to the back of your print. All it needs is your name and address, together with details of the place you have photographed. It might also be possible to add brief details to a 35mm slide mount, or to the plastic sheet in which a medium or large format transparency is stored after processing. Failing that, go for the second line of approach. Ensure

your name is on the slide, but put all the captions on a separate sheet of paper, each one numbered and matched up with corresponding numbers on each slide mount. If your larger format work isn't mounted, you can just as easily number the plastic sheathes with small labels. The separate caption sheet should, of course, also include your name and address.

In the vast majority of markets, it is not necessary to include technical details such as apertures and shutter speeds. Most magazines are interested only in the subject, not how you took it. The exception to this rule is the photo press. In this market the main reason for buying the picture is the technique, although it should be a technique that is carried out on an interesting subject, rather than a boring one. In this one market, then, you should include, along with your name and possibly the place where the picture was taken, the aperture and shutter speed used, together with any other relevant technical details: filters fitted, focal length of lens, whether or not a tripod was used.

More detailed captions

So far we have talked about captions used only to identify pictures. Now we come to captions that are used to add more detail. They are captions which describe a set of circumstances referring to something in the picture. You see them, for example, used with humorous or off-beat pictures such as the funny road sign or the unusual vehicle that might be printed as a filler piece in a motoring magazine. They are, in fact, like articles in miniature, but with one big difference.

With an article, the reader looks first at the words, then refers to the pictures to learn more. With a picture caption, the reader looks first at the picture, then turns to the words to find out what it's all about.

When you write a caption of this type, you need to be brief and to the point. You have probably intrigued your reader with the picture and you now have to explain what's going on. Let's say, for example, you are captioning a picture of an unusual, twisted spire on a church. It's the sort of thing that probably isn't strong enough to make a complete article, but as a one-off picture with a good, strong caption, it might sell to the local county magazine for the area, or to perhaps a national magazine dealing with the English or British countryside.

The first thing you need is an eye-catching sentence to grab your reader's attention. How about:

Here's a new twist on an old theme.

That links the picture to the words and encourages your reader to move on to find more information. How do you know what sort of information is required? Simple. You put yourself in the reader's shoes.

Ask yourself: supposing I saw this picture and had never seen the subject before, what would I want to know? Sticking with that example of the church with the twisted spire, you'd probably want to learn the name of the church, where it is, how it got like this and what sort of reaction it gets from the locals. Assuming you had done some research to that effect when you took your picture, here's how you could write that particular caption:

Here's a new twist on an old theme. Instead of going straight up, the way church spires are supposed to, the spire of St. Mary's Church in Little Boghampton twists, bends and curves its way 200 feet into the sky. The spirally spire is the result of a particularly stormy night in 1822. The morning after, villagers woke to find their church spire had mysteriously left the straight and narrow. And it's been that way ever since. Bet it gives the bell ringers a bit of a turn!

A caption like that is all that's needed to add a little spice to the right kind of picture. Notice how it gets across all the facts, but treats them in an amusing way. That's because it is an amusing picture to begin with. Other subjects, which might be more serious, would naturally be treated in a more serious way when adding words.

When you caption a picture like this, use a typewriter or word processor set up for double spacing. Type or print the caption on a single sheet of paper and attach it to the back of the picture if it is a black and white print, or attach the transparency to your caption if you are supplying colour.

Writing an article

We've already dealt, in a previous chapter, with how to gather facts for articles. Here, then, we will look more closely at how to get those facts down on paper in a simple but professional style. Let's start with the technical, rather than the artistic aspect.

First of all, journalists don't refer to what we're talking about here as articles. They call them features, and the words that go to make up those features are called copy.

How you present your work is of as much importance to the writer as it is to the photographer. An illegible, hand-written scrawl will give editors the impression that they are dealing with an amateur, and you need to be professional from the start.

So learn first how to set out a manuscript the way professional

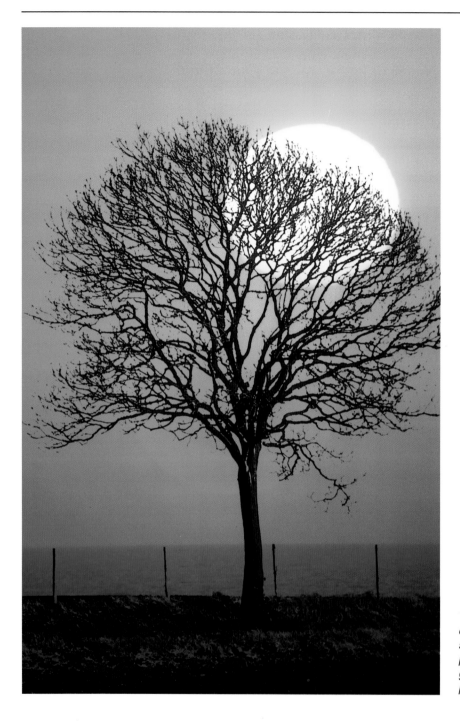

Two holiday subjects combined in a slide sandwich – the sort of picture that makes a good illustration for a photo press article.

writers do.

First, and most important, it should be typed, or printed from a word processor, not hand-written. You should use A4 size paper, with the words printed on one side only and double-spaced. Number each sheet in the top right-hand corner, then at the bottom of each sheet write "m.f." standing for "more follows". At the end of the article, write "ends", followed by the number of words

in the article – easy if you have a word processor, a little more time consuming if you are typing the article, but still worth the effort if you want to appear professional.

Attach a cover sheet to the front. On this, in the centre of the sheet, write the title of the article, your name and, again, the number of words. Lower down, put your name again, your address and telephone number, preferably a day-time number as well as a home number if you are allowed to receive private calls at work.

So much for the technicalities; let's start writing.

Organising your thoughts

Your first priority is to organise your thoughts. If you gathered your original information by making notes in a notebook, then flick through it and get a feel for the kind of information you are dealing with. If you used a tape recorder, then play the tape through, making rough notes on the salient aspects of the interview. Once you've done that, you will begin to see how various aspects of your story fit together.

Don't make the mistake of thinking that when you come to write the story, the facts have to fall in the order in which you asked the questions. Something that was said half-way through the interview might be the most important aspect of your story and so will make a good starting point. Something that was said at the beginning might link naturally with something else that was said at the end, so the two quotes can be tied together. Your purpose is to make a good readable account that keeps the reader entertained, not to produce a verbatim report of an interview. Likewise, if you have gathered facts separately from your interview, introduce them into your story at relevant points, where they can be tied in with something the subject has said, or used as a preamble to a quote from your subject.

The only time you work differently is when you are writing one of those question and answer type of features in which you detail your question, followed by the subject's answer. Even then, however, you can rearrange the order of the questions if it makes for a more logical read. However, that type of feature isn't as popular as it once was, so it's probably best to write your article in the more traditional way.

Either way, take a look at the style of the magazine at which you are aiming. There are three basic styles of magazine writing and, whatever your intended market uses, that's the style you should adopt.

The first is that question and answer style. No, it's not as popular as it once was, but if the magazine you want to write for seems to be still using it, then that's the way to do it.

The second style is the most common. It involves simply an account of the subject, written in the third person, giving facts and attributing quotes to people you have interviewed.

The third style is similar to number two, but is written in a more personal way. You write it in the first person, talking not only about the subject, but about your own reaction to it. This is a style that is becoming increasingly popular today and can be seen at its best in magazines like *TV Times*.

Your last important job, before actually writing, is to check the length of the features in your intended magazine. The tendency these days, in most popular magazines, is to run quite short features, no more than 1,000 words at a time. In more serious magazines more depth is required and features might run into several thousands of words. Get a rough idea of what your market needs by counting the number of words to the average line, then counting the lines and multiplying one by the other.

Once you know what's needed, stick to it. If your magazine seems to be using most of its features at around 1,000 words, there's nothing wrong with writing one that takes only 900 words or perhaps goes to 1,200. But write a feature of only 300 words, or one that tops 2,000 or more, and it will probably be rejected on length alone, irrespective of subject matter.

Three steps

A good magazine article breaks down into three steps: the beginning, the middle and the end. That is to say that you first need an intro, you then have to deal with the subject you are covering in detail, and you finally have to round the whole thing off with a nifty turn of phrase.

So start with your intro. This is the first paragraph, written to grab the reader's attention. It has to sum up, in just a few words, what your feature is about, but not give too much away. You do, after all, have to keep something back to keep the reader reading the rest of the article. Make the intro simple. Keep the sentences short and sharp. Pull the readers in and intrigue them. Look at the first paragraph of any feature in a national magazine and you'll see exactly how this works.

The biggest difficulty for many writers, both beginners and the more experienced, is thinking up a good, snappy intro. To some, it comes naturally, others have to work at it and, as a beginner, you'll probably have trouble to start with. So here's a tip to get you over that hurdle. If you can't think of a good intro, write a bad one – anything about the subject that comes into your mind. Then get on into the main part of the story. Once you have written a dozen or so paragraphs, there's a good chance that a new intro

will suddenly occur to you, and you can then go back and rewrite your first thoughts.

Which brings us to the body of the feature. Here we take the points made in the intro and expand on them, bringing the reader the full facts. Don't try to be too clever at this stage. Just state the facts in a straightforward way, keeping everything as simple as possible. This is where the answers to the basic questions – who, what, when, how and where – are answered. But don't feel you have to incorporate every single thing that your subject has said, or every single fact that you have gathered. Only include points which are genuinely interesting and relevant to the subject in hand. Don't ramble off that subject in your feature, even if the person from whom you got your information rambled off at the time of the interview.

A good rule of thumb is to ensure that you yourself are actually interested in what you are writing. If you find the subject boring, what hope do you have of interesting a reader?

At the end of the article you need a way of rounding things off. You need a punchline. Something that leaves the reader feeling satisfied or perhaps with a smile on their face. One way to do this is to sum up how the person starring in the feature feels about the future, in connection with the subject in hand. Or perhaps there is a joke or some kind of light-hearted comment that someone made half-way through the interview. If it sounds like a good rounding-off comment, then keep that back and use it at the end.

Writing it down

Just as important as what you put into your feature is the way you actually put it all down on paper. Here we're assuming that you have a basic knowledge of English language, the way you learnt it at school. To write a successful freelance feature, you really need little more than that. You certainly don't have to know the finer points of English grammar as it would be taught at A Level or beyond.

In fact, writing journalistically is often more a case of breaking rules rather than enforcing them. So, providing you are putting across your point in the right kind of way, there's no harm in starting sentences with "but", or even "and" – strictly taboo in what some might call "correct" English.

Never use one long sentence when you can break up what you have to say into two or three shorter ones. That helps to keep things simple and readable.

Break the copy up, not only into short sentences, but also into shorter-than-usual paragraphs. If you remember what you learnt about English at school, you probably think that you shouldn't

English villages make good starting points for articles about the area where you take your holiday, useful for county magazines, as well as holiday publications.

end a paragraph until you have finished a particular line of thought. When you write for a magazine, you start new paragraphs, not so much for reasons of grammar, but for reasons of layout.

Most magazines are laid out in columns, three and maybe four to a page. A whole column without a single paragraph break looks ugly. So you need to break up the copy every three, four or five sentences, depending on their length. The longest your paragraph should run is around sixty or seventy words, and it is quite common to write paragraphs of no more than one line.

Quotes also help to break up your copy in an attractive way. A whole page without quotes makes dull reading. But write a few paragraphs, followed by some quotes, then some more descriptive copy and more quotes, and immediately it looks so much better.

However much you organise your thoughts in advance, there will come a time, while you are writing, when you realise that you've come across some fact or quote, or thought of something, that would have been better said earlier on. This is when working on a word processor has a strong advantage. Wherever you are in your text, it's easy to go back to an earlier section and simply insert new copy before the final print-out. If you are working with a typewriter, it is more tiresome to add new copy to earlier sections, but don't let this make you lazy. It's still worth doing to make the feature as readable as possible. Just go back and mark your copy where you want the addition to be made, then type that on a separate sheet of paper. You can insert the new copy in its proper place when you type the final draft.

To be honest, word processors have made the freelance writer's work much easier, because it is so simple to insert or

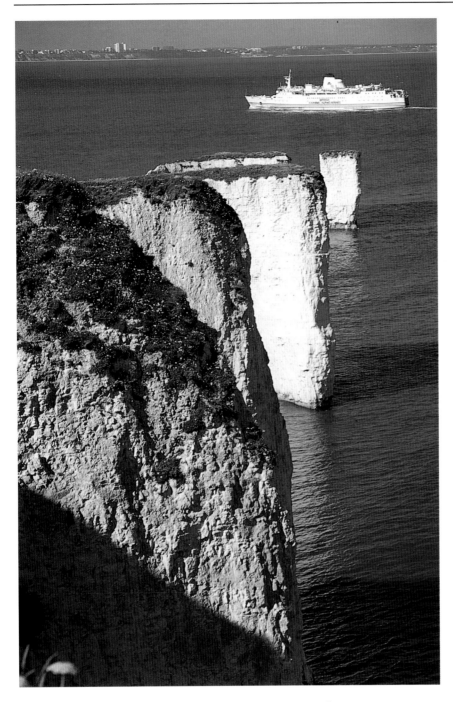

Take a picture like this on a cliff-top walk, add other pictures along the route, describe the area in words, and you have the basis for an illustrated feature in a walking or rambling magazine.

delete whole sections of text and place them wherever you want them. Many experienced writers don't even take the trouble to organise their thoughts before they start these days. They merely go through their notes, or listen to a tape, putting all the relevant information in different places within the feature as they go along. Very often, even the intro is left to last, by which time the writer has the best possible feel for what needs to be said in that all important paragraph.

Finally, once the feature is written, leave it for 24 hours, then come back to it and read it afresh. You'll be amazed how many improvements you find to make. Watch out for common traps, like using the same word two or three times in the same paragraph, or even the same sentence. Beware too of using two words that mean the same thing, especially when describing something: a "tiny little" flower, is better described as merely "tiny" or "little", not both, and if it really is so small, then maybe an entirely different word, like "minute", would be better. In fact, as you go through your copy, take out any words that are superfluous. It makes for tighter writing, the chance to get more information into the article and, at the end of the day, a more enjoyable read.

More captions

Most of this chapter has been dedicated to writing articles, but we must not overlook the pictures. These are, after all, illustrated articles. So, once again, we come to the subject of captioning pictures, and once again we have a slightly different approach to consider.

When you write an illustrated article, the picture captions should be added to the end of the text. Simply number the pictures, either on the back of prints or on the slide mounts, then match them up with a separate caption sheet, added to the end of your feature. On this, write each picture number against a short caption that sums up the picture and very briefly repeats something that has been said in the text.

Do not simply call the pictures "fig 1", "fig 2", "fig 3", etc, with reference to the fig numbers within the text. If you do that, you make life difficult for the editorial staff, since it means they either have to use every one of your pictures or, if they decide to miss out one or two, they then have to amend your text, deleting the references to them. Also, readers tend to like to flick through magazines, looking at the pictures and reading the captions before getting into the actual features. So good captions help to pull the reader into the main body of your article.

The best bet, then, is to supply more pictures than would be needed, giving each an individual caption that stands or falls on its own account. Editors and their staff can then use the pictures they prefer, as far as both content and the layout of their pages are concerned.

End at the beginning

When you come to the end, you need to go back to the beginning, because now you are going to give your feature a title. It is rare for a writer to start with a title, it's more likely that one will suggest

itself to you as you work your way through the project.

Titles should be simple and straightforward, never more than a few words. If you can incorporate something amusing, or a pun perhaps, into the wording, then so much the better. Don't worry if you don't feel too inspired at this stage. When in doubt, write something straight and even boring. The fact is that it is a rare editor indeed who lets a title put them off buying a well-written and interesting feature. In any case, however clever or erudite your title may be, it's almost certain that it will be changed by the time the words see print.

That's because titles are largely the responsibility of the magazine's sub-editors. They write a title for more than the obvious reason of summing up what's in the feature – it also has to fit in with a specific kind of layout. It will have to fit a certain space on a page, or perhaps work in conjunction with a picture into which it has been inserted in full or in part. Either way, the shape and length of the title is as important to the sub-editor as its actual wording.

So don't be surprised or disappointed if what you considered to be a minor work of art in titling is completely disregarded. It's not personal, it's layout.

DOING THE BUSINESS

The holiday's over. You've taken all your pictures and gathered all your facts, ready to start selling. Now it's time to get down to business.

If you've been taking notice of everything that has been said in this book, you should have at least one and possibly two types of film to process: colour slides and black and white prints. If you've come home with nothing but colour negative film to make colour prints, then you haven't been paying attention. Because, at the risk of repeating what has been said before, yes you can sell colour prints to a few markets, and yes it's true that more markets are accepting them today than just a few years ago. But the true professional – and that means you, if you are serious about selling your pictures, and whether you actually earn your full-time living from photography or not – takes only colour reversal film to make transparencies, still demanded by the vast majority of quality colour markets.

Processing colour slides

Let's start, then, with those slides. Are you going to process them yourself or are you going to have them trade processed? If you have been shooting Kodachrome, then you have no option. Kodachrome is a colour slide film that uses a chemistry and a structure that is unique to Kodak. In the UK it cannot be processed by independent laboratories and you can't buy the chemistry to handle it at home. You have no option other than to send it off to the address detailed on the instructions that came with the film.

Any other conventional colour slide film uses a process called E6 which can be handled by yourself in a home darkroom or by an independent processing laboratory. If you are familiar with black and white processing, you might like to try E6 colour slide processing for yourself. Complete kits are available, but they aren't particularly cost effective if you have only one or two films to process occasionally. If you are returning from a holiday with a lot of film, however, then it becomes more viable.

Full instructions are supplied with the kits, so we won't go into

Look critically at your pictures to make sure the most important part of the subject is correctly exposed.

the actual process right now. Beware, though. The process is a lot more precise than developing a black and white film. Timing is extremely important to parts of the process and the temperature at which you have to work is higher than the usual room temperature at which monochrome is developed. Also, you have to ensure that the temperatures are kept constant throughout much of the process, preferably in a thermostatically-controlled water bath. If

you don't do this, all sorts of problems can result, ranging from under or over developed slides to bad colour casts appearing across the image.

So unless you are confident about colour processing and have done it before, don't risk your valuable holiday slides at this stage. It is probably better to have your E6 films trade processed, the way many professionals do.

You can't get this done easily at your local high street minilab. You might get it done through a photographic shop or by sending your films to an address given on the instructions. But, to be honest, this isn't the best way, because they will inevitably mount every picture and charge you accordingly. By the very nature of the work you do as a freelance, it is unlikely that you are going to have a use for every single picture you took. Maybe you bracketed exposures on some of them to make sure you got everything just right. Maybe on another subject you took three or four different pictures from different angles, but anticipate using only one for selling purposes. Either way, you don't want to go to the expense of having every single frame mounted.

The alternative is to go to a professional film processing laboratory. You'll find many listed in the classified advertisements of photographic magazines, or you might find one local to you in Yellow Pages. If you choose a lab from a photo magazine advert, look for one that makes a point of saying they handle E6, and pick one that has a decent-sized display advertisement, rather than someone who advertises in the lineage columns: they might easily be amateurs who do home processing as a sideline and, while many of them should be okay, why take the risk at this stage?

If you go to a local laboratory in person, once again make sure they handle E6, rather than just colour negative film and prints (that process is known as C-41). A good professional E6 laboratory will have at least two processing runs a day, so if you take your films to them in the morning they should be ready in the afternoon; take them in during the afternoon and you'll get them back early on the next working day.

Wherever you go for the service, ask them to process the film only and supply it back to you unmounted.

Processing black and white

Unlike colour slides, black and white film is best developed and printed by yourself, purely because of cost. These days commercial laboratories are simply not set up for handling black and white the way they handle colour, and so the processing is expensive. Again there are small processors advertising in the photo press who will handle black and white on your behalf, and it's

true that many of them turn out reasonable work. But a lot of people have been caught by getting inferior results from these advertisers. The only real way to get the kind of top quality black and white processing demanded by the freelance market is to go to a top professional laboratory, which can be an expensive exercise.

Or do it yourself. Black and white developing and printing isn't as difficult as it might at first seem and, once you get the hang of it, you can turn out the right kind of quality while having the advantage of being able to selectively enlarge your pictures in exactly the way you want to present their subject matter.

There are some good books around on darkroom technique that will tell you how to get the best from black and white in a home darkroom, so we won't go into all the technical details here and now. This book, after all, is about how to sell your pictures.

Processing colour prints

Yes, despite everything that has gone before, there will be some markets for colour prints. You might, for example, be thinking of selling original photographs as art to hang on a wall, rather than for publication in a magazine. That's one area in which colour prints would obviously be of more use to you, so let's touch briefly on their processing.

If you have your own darkroom and already have experience in colour printing, then you need no further advice. But what is the best way to handle trade colour processing? The obvious way is to take your pictures to a high street processing lab. They are cheap and good at giving you adequate results. But the prints they produce are machine made and can never match the quality of a good hand-made print.

On the other hand, there is rarely anything wrong with the development stage which turns your film in strips of negatives. One good way to work, then, is to take your film to a high street lab, but to use the prints only as proofs. From these, you can pick those which you want handled better, then have these hand-printed, to a specific size and with the exact cropping you need, at a professional photo laboratory. Once again, you'll find these advertised in the photo press and in your local Yellow Pages. But when you deal with them, do make it clear that you want hand prints, not machine prints – and be prepared to pay more for them.

Go for quality

With your prints and transparencies processed and ready for submission, it's time to start being ruthless. If your pictures are going to succeed, they must be of the very best quality. So go through

them very carefully and reject any that don't come up to scratch.

Make sure that they are as sharp as possible. If your intended market is one of those that demands sharpness all the way through the picture, then check that you have got the correct depth of field. Look very carefully at exposure, especially on colour slides. With prints, slight discrepancies in exposure on the original negative can be countered at the printing stage. But with reversal film, what you put through the camera becomes the slide or transparency.

Exposure, therefore, should be spot on. If you have heard the old saying about printers preferring under-exposed slides, forget it. It's true that a good printer can penetrate the depths of slight under-exposure and get a workable reproduction from it, but generally they prefer the richness of colour saturation that comes from perfect exposure. The worst crime you can commit is to supply a colour slide that is over-exposed. Over-exposure washes out the colour to a pale image and no printer can put back what isn't there in the first place.

Look too for damage. Slides that are scratched or prints that display unwanted lines that have resulted from scratched negatives should also be thrown out. Likewise, black and white prints made from dusty negatives. If your print shows little white marks, then print it again. Look particularly at sky areas, in which marks and scratches show most prominently.

Sorting for markets

Once you have the right quality, it's now time to check that you have the right pictures for the right markets. This is no time to start trying to kid yourself. We've already spoken at length about the needs of various markets, so by now you should know what you are aiming to submit and why.

Look first at the types of picture you have. Are they the kind that will stand on their own and therefore be submitted for a magazine's file use or for single picture markets, such as brochures or calendars? If so, you now need to sort them into categories, working out what pictures are going to which markets. When you have done that, label them with your name and address and a picture number which refers to a caption on a separate sheet of paper. If the pictures are to be used as illustrations for articles, then separate them out and put them aside for when you have written the article or articles.

If you are using colour slides, then now's the time to "spot" them. When you come to think about it, there are eight different ways of viewing a slide, and while only two of them show the subject the right way up, only one of them shows it the right way

round. If you are in any doubt about which way this is, take the slide close to a light source and turn it so the light reflects off its surface. The slide has a dull side and a shiny side. The shiny side is the correct one for viewing. When you know which way round and which way up the slide should be for correct viewing, place a spot in the bottom left-hand corner of the mount. You can buy self-adhesive spots for the purpose, or you can do it neatly with a felt-tip pen or ballpoint.

Now's the time to look at your work objectively, the way an editor or a picture buyer will. So ask yourself if the picture or article that you are proposing to submit really fits the requirements of a particular market as you have come to understand it.

If the answer is "Well, it's not exactly what I've seen them using in the past, but they might make an exception for me", then it's time to rethink.

If the answer is "Actually, they don't use this kind of work, but maybe they would like something different for once", then you still haven't got the hang of this business.

If the answer is "Definitely and without doubt yes", then go ahead and submit.

Making a submission

To understand the best way of dealing with editors, or most other picture buyers for that matter, it is a good idea to learn something about the way they work.

Editors, contrary to some people's belief, are not high and mighty characters who look down on the mere mortals who wish to supply them with words and pictures. On the contrary, they are business people, who need your work if their business is to survive. On the other hand, they are also extremely busy people who have no patience with time wasters. Remember those two things and you'll get on fine with the average editor.

So give them what they want. Present it professionally. Make it easy to look at. Make it easy to deal with. And don't expect detailed reactions to your work, either favourable or unfavourable. If an editor spent time telling all those whose work he rejects why he doesn't want it, he would have no time left for his day-to-day business.

We've already dealt in detail with giving editors the work they require, so let's look now at how you present it. Prints should be 10x8 inches in size and made on glossy paper. It doesn't matter too much whether they have borders or not. Slides, if they are 35mm, should be card or plastic mounted without glass (glass mounts invariably shatter in the post), then slipped into those plastic filing sheets that take around 20 slides at a time. If you are

using medium format transparencies, they needn't be mounted. You can leave them in the plastic sleeves in which the processor returns them. But cut them into individual images while still in the sleeves and slip those into filing sheets – you can buy these for many different picture size from 35mm up.

Presenting your work this way makes it easy to throw a sheet on a light box and take in a whole set of slides at a single glance. If the editors like what they see on this first glance, then they will start to look closer at individual images.

Both prints and slides should be packed in a stiff-backed envelope, or in an ordinary envelope with stiff cardboard cut to size, to protect the pictures. Don't over-wrap your pictures. Don't, for example, put the slides between sheets of card, then smother it with that heavy-duty brown adhesive tape. Difficulty in getting at your pictures might lead to a loss of patience, which in turn could even lose you a sale.

Add a covering letter, but don't write too much. This is not the place to tell the buyer too much about your submission. A magazine editor wants to know basically what you are submitting – pictures only, illustrated article – and, where appropriate, the department within the magazine at which they are aimed. A picture buyer for calendar, greetings card, brochure or postcard companies wants only to know how many pictures you are submitting and the area where they were taken. In either case, don't list all the pictures and their details in this letter. Those details can go on the caption sheet with the pictures, or perhaps in an article.

At the end of the day, your work will stand or fall by its content, not by any reasons or excuse that you have to offer for it in a covering letter.

If you already have some headed notepaper, then use it. If you don't, consider having some printed. At the very least, have the letter typed or printed from a word processor. Hand written letters look amateurish and spoil the first impressions – and in this business, when everyone you are dealing with is super busy, first impressions count for a lot.

In this letter, you should always address the editor or picture buyer by name. If you don't already know the name, from the title page of a magazine, for example, then make a phone call and find out. You won't have to speak to the actual editor or even the magazine, the person on the switchboard should be able to tell you what you need to know. Check the name, even if you have got it from a directory like *The Freelance Photographer's Market Handbook*. Remember that these directories are printed once a year and things change during the course of twelve months.

Always mention at the end of your letter that you are submitting the work for use at the publisher's normal rates. This shows

that you have a professional attitude and that you expect to be paid.

Finish by saying that you look forward to hearing from the editor or buyer at their convenience and then enclose a stamped addressed envelope for the return of your work should it prove unsuitable.

If you are sending your work abroad, you naturally can't put British stamps on the return envelope. Instead, buy International Reply Coupons to the value of the return postage. You can get these at any post office and the person who receives your work in a foreign country can use them to pay the return postage in stamps of their own denomination.

Handling the money

Once you start to make sales with your pictures, you'll have to understand ways of handling your money. You won't need an accountant as such, because the basics are quite simple. But if you don't look after monetary matters right from the start, you're going to get into trouble later.

Until now, your only experience of paying tax is probably to have looked with dismay at the stoppages in your wage packet. This system is P.A.Y.E. – Pay As You Earn. Your employer works out how much tax you need to pay, based on the money you are earning, and deducts it on your behalf. They do the same with your National Insurance stamp.

When you work for yourself, you have to pay your own tax. This means declaring what you have earned during the year on the tax return which comes through your door around March. If you don't already get one automatically, then you should ask your nearest tax office for one. Once you have made your first declaration in this way, you will be put on what's called Schedule E. This is for self-employed people.

All you have to do then is make a note of your earnings through the year and, when tax return time comes around, you fill in that amount in the appropriate box. The forms are quite easy to understand, but if you have difficulties, someone at your local tax office will help you.

The tax office will then assess you on your earnings and eventually send you a bill for the tax you owe, based on the current percentage.

Not all is doom and gloom, however. You don't have to pay tax on every penny that you have earned, because you should have some legitimate expenses. These include anything and everything that you have personally had to spend in order to operate your business: the cost of film, processing, writing materials, books for

research, petrol for getting to locations, part of your home telephone bill, heat and light in your darkroom, a new camera, lens, or any other piece of equipment. You can even charge a certain percentage of your holiday, but don't overdo it. No taxman is going to believe that the only reason you took your holiday was for freelance purposes. But once you can show success in selling pictures taken on holiday, you can charge part of it against tax. Around 25 per cent of the overall cost is about right.

So you need to keep books during the year. At its simplest, you need to make two lists. One shows your income, the other shows your outgoings. On the income list, detail who has paid you what and when. On the outgoings list, show all your expenses and match each entry up with a receipt that covers that particular item. A simple number on the receipt against the same number in your accounts book is all it takes.

Then, when you complete that tax return, list not only what you have earned, but also what you have spent. The taxman will deduct one from the other and charge you tax only on the actual profit made after expenses. In fact you probably won't have to pay any tax at all the first year you are in business, but don't think they have forgotten about you. Always keep some money put aside, ready for when the tax bill comes. The best idea is to deduct a certain amount from each fee that you earn and put it in a building society. That way, it earns extra money in interest while you are waiting for the annual tax bill to arrive.

This is book-keeping in its simplest form for the freelance who supplements another income with their holiday photography. But if you are so successful that you can afford to go full time freelance, then you will need to keep more detailed books. You will also have to pay your own National Insurance, since no other employer will now be deducting its cost for you.

Once you begin to earn a really substantial income you might also have to register for VAT. The amount you need to earn before registration is mandatory changes at regular intervals, so we won't quote an actual figure here. Check that one out with the local VAT office or any accountant. If you are registered for VAT you need to add a certain percentage (also changeable with time) on top of your normal fee. Professional companies won't object to this, since they too will be VAT registered and can claim back any VAT they they have paid you. Likewise, you can now claim back VAT that you have been paying out on items like film, processing, petrol, etc. So, far from being the burden that many people think VAT to be, it is actually a great help to the small business person, in that it saves money on anything bought for the business with VAT on it – and that means the vast majority of items.

If all this begins to sound complicated, don't despair. If you are

earning enough to support yourself full time then it is certainly worth employing an accountant. The money that professional accountants charge is worth every penny, since they can often introduce you to savings that you would never have found for yourself. Good accountants pay for themselves, and you should never shirk from employing one once your business takes off.

If you are not VAT-registered, then you don't have to write invoices. Many magazines, in fact, work on what is called a self-billing invoice system, which means they invoice themselves on your behalf and simply send you a cheque.

If you do register for VAT, then you must write invoices to everyone for the record. If that's the case, or if you work for a client that does need an invoice, don't worry. That too is simple. You can buy invoice books in any good stationer. All you need put on them is your own name and address, the name and address of your client, and the amount owed.

What you should never do is try to dodge paying tax, however little you earn. Remember that your fees are tax deductible to the people who are paying you. They will claim your fee as one of their legitimate expenses in exactly the same way as you claim for, say, a roll of film on yours. Those claims go to the government and so somewhere there is always a record of the fact that you have been paid. And the golden rule of taxes is this: They Always Catch Up With You In The End.

Organise your finances correctly and reasonably and you'll never get questioned. Try to get away with something you shouldn't and, sooner or later, you'll land yourself in a lot of trouble.

HOLIDAY CASE STUDIES

There's nothing quite like personal experience, when it comes to learning about selling your work. So let's spend this final chapter meeting some freelances who have had success in making money from their holiday pictures, learning how they recognised the potential for a sale and how various projects were carried through to final success.

JOHN BLAY

A few years ago, I travelled to Brittany with a company called Eurocamp. In their brochure they do, in fact, ask their clients to send any pictures which may be suitable for future publications. I took them up on their offer and sent a small selection of slides, taken on the camp site and on the beach.

They accepted two and their fee at the time was £30 per reproduction. They advised me beforehand that they wanted to use two so I looked forward to a cheque for £60.

A week or so later a large envelope arrived containing three brochures, two of which were subsidiary companies. There was a cheque for £160 as one of the slides had been reproduced in all three. As well as returning the slides they had made a Cibachrome copy of each.

Another success was with *The Lady* magazine after a holiday in Snowdonia. I wrote a 2,000 word report on the trip and illustrated it with a good selection of monochrome prints. I was very pleased with that success, as writing for profit was new to me.

NORMAN ROUT

In 1988 I also had a family holiday in France with Eurocamp. Whilst preparing for this I read in their *Holiday Guide* that they would pay £30 each for any shots used in their brochures, £60 for a cover. In view of this, I took rather more reversal film than, as a family man, I would normally be able to justify – about £75 worth, including processing.

Two of my shots were used in Eurocamp brochures and my

family and I have subsequently had free holidays in Normandy, Brittany and the Loire Valley in exchange for my doing brochure photography.

A couple of years later I read in the BFP *Newsletter* about the intended launch of *France* magazine. I submitted a number of slides taken on my first Eurocamp holiday and during an eight-day break my partner and I had in Paris the following year. In the first issue they used three, one of them full page. The next year, four more were used.

Apart from the above successes I have also had a shot of Mont-St-Michel in Sealink's *Duty Free* magazine, a night-time shot of the Eiffel Tower in a supplement for a Paris Travel Service brochure and, the best yet, a double-page feature about Carcassonne in an issue of *Choice* magazine.

DAVE WOODS

When I bought my first SLR, I soon discovered that photography could become an expensive pastime and began exploring ways in which I could make my photography pay. Living as I do in an area of mid-Wales visited by thousands of tourists every year, I decided to concentrate my efforts on this area.

I spent some time and many rolls of film photographing the most well-known places and visiting as many different events as possible. With such diverse subject matter as the Llandrindod Wells Victorian Festival and the Man versus Horse race at Llanwrtyd Wells, my photography improved in leaps and bounds until I was confident that I could tackle any subject within the limitations of my equipment.

A selection of the best shots were sent to the Tourism Officer of Radnor District Council, who immediately bought the rights to use a shot of the Victorian Festival on the council's stand at the Caravan and Camping exhibition in Birmingham. Several shots were then chosen for their official guide to Radnorshire.

During this time I continued shooting as many places and events as possible and was rewarded with publication in several issues of *Amateur Photographer* and *Bicycle* magazines. Six shots were then chosen for the Heart of Wales tourist brochure and I have since been asked to provide several more.

MARGARET BICKMORE

On a visit to Jersey, around twenty years ago, the sight of Corbiere Lighthouse gleaming white against the blue sea and sky at the end of a rocky causeway made my holiday. I took a picture from the cliffs.

Later, as the light began to change, I realised that the sun was setting seawards and the sky was glowing orange and red. It would be worth getting back to get a shot of the lighthouse and the sunset. As usual, since I wasn't thinking like a freelance in those days, I prudently rationed the film and I took only one picture. The lighthouse and rocks silhouetted in the fiery orange sky, with the golden sun resting on the horizon, became my favourite holiday photo.

The years went by and I eventually became involved in freelance photography. That was when I submitted a portfolio to Lion Publishing. Much to my delight, the Corbiere sunset was used to illustrate the story of John Newton and his hymn *Amazing Grace* in *The Lion Book of Famous Hymns*.

The sting in the tail? To offset the text more effectively the photo was printed in reverse!

GEORGE GRIBBEN

I've had two unexpected sales from holiday pictures. The first was when I was showing an overseas friend a part of Dartmoor. We got lost, took the wrong turning and ended up at a thatched cottage village.

My friend started taking pictures, but the only camera I had was an old fashioned 6x9cm bellows camera. Nevertheless, I took two shots and on development found I had a very good transparency. I noticed *This England* was on the lookout for this type of picture and a fortnight after submission I had a reply asking permission to keep the transparency on file.

Some 15 months later, a large envelope arrived. Inside was a calender from *This England* and on the month of August was my picture.

My second holiday sale was sparked off by an item in the BFP *Market Newsletter*, reporting that *Trout and Salmon* magazine was extending its colour pages and would like scenic shots with fishermen in Scotland.

I asked the editor if he would like to see shots of the river Ness at Inverness and river Ochy at Fort William, taken on a previous holiday, and he replied with a swift "yes".

Twelve exposures of the two rivers with scenic backgrounds and fishermen were accepted.

JEREMY BURGESS

Heading toward the Lake District, driving up the A1, one passes Ferrybridge power station. I stopped, climbed an embankment and took one exposure of the steam from the cooling towers, in

black and white. After the holiday I hand-coloured this in two versions: one black, blue and yellow, the other black, blue and red.

That was about four years ago. I then lodged the pictures with a scientific picture agency. To date one has sold 18 times for a total of about £900, the other 16 times for a total of about £700. Their life is not yet at an end, and I think £1,000 for each version is attainable.

Uses include *Radio Times,* various women's magazines, environment magazines and editorial uses in France, Germany, Holland, Italy, Japan and Australia. A good return on one frame of black and white film and a few hours of colouring work, costing about £20 in materials.

The lesson, of course, is don't think you have to go to exotic places to make picture sales. What you have to do is take the right picture, know how to market it, and preferably produce something a bit different. The number of photographers passing Ferrybridge power station each year must be huge, and no doubt most of them think it's not worth stopping for such a hackneyed subject.

Well, they're wrong.

REGINALD FRANCIS

I have a couple of unusual holiday pictures that have made sales for me.

The first was taken when I was sailing with a friend on a very hot, sunny day. The wind was very light and we decided that a swim would be in order. As we were far from land and there were no other craft around we decided that trunks were not necessary. When it was my turn I decided to show off with my speciality: a duck dive.

Unbeknown to me my friend had picked up my camera and, as I performed a perfect duck dive, he pressed the shutter to obtain a picture of the curvaceous part of my anatomy which is not normally on show.

Entitled "The End of Reg", it was published in *Amateur Photographer* with the comment, "Your impersonation of a cheeky water fowl is most impressive."

The second picture was taken in Egypt when I was walking through the native quarter. It is of an Arab smoking a pipe with a long stem, the bowl of which was a Simonds beer can. The picture included his small son who was looking at the camera with an expression of wonder.

I called the picture "The Dual-Purpose Beer Can!" and sent it to Simonds Brewery, who used it as the cover to their house magazine. They sent me a charming letter and willingly paid the fee I asked for its use.

BRENDA BICKERTON

Several years ago I sold four pictures to a brochure entitled *Cottage Holidays*. This resulted from one picture I took on a day out in Dorset.

The picture that started the sequence of events was the Post Office at Rampisham, Dorset — a nice old thatched cottage. This was used as a cover picture on *Dorset Life*.

As a result of this I received a phone call one day from an agent asking if I had any more pictures of cottages and country-side scenes. I sent them a big selection and four were subsequently used in the brochure for the following year.

CAROL KIPLING

Over the years I have sold a number of photographs taken on holi-day, though always as part of an illustrated article. Most of these have been touring features for the caravanning magazines.

My most successful holiday, in freelancing terms, was a fort-night spent touring with a caravan in South Wales. On our return I sold two full-length illustrated articles — one on the Brecon Beacons to *Caravan Magazine*, and one on St. David's to *Caravan Life* — and a shorter piece on a site we'd used to *Practical Caravan*. Altogether I was paid £240, which went a long way towards pay-ing for the family holiday. I have also sold photographs with arti-cles to *The Lady*, and the local county magazines. Some of these are not, strictly speaking, holiday photographs, but I apply the same principles to my home area and take advantage of local weekend trips.

Writing the articles is fairly easy, requiring only some first-hand description, a good guidebook and a little research in the local tourist information office.

MIKE GERRARD

About three years ago I went to the Pindus Mountains in northern Greece, on a walking holiday for the travel pages of *The Sunday Times*. Also on the trip, by coincidence, was an American writer, who said that she sold the occasional travel article and although this was a holiday, she might try writing something about it when she got back.

We kept in touch, and a couple of months after getting home I had a phone call from her one lunchtime. "Help!" was the basic message that came across the Atlantic. She had indeed written an article about her walking holiday in the Zagorian villages of the Pindus Mountains. She had also taken lots of photos to illustrate it

but, on her way home, she had dropped her bag on the airport tarmac.

The bag had a few precious things in it that she wanted as hand luggage: her camera and exposed film... and a bottle of Greek red wine. The bottle had smashed, soaked her camera and also soaked into all her rolls of exposed film. None of them was processable.

Could I help, as she had sold the piece to *The New York Times* and they wanted photos.

Her bad luck was my good luck, as I was able to send her about a dozen 10x8 prints, of which *The New York Times* used several and paid me, if I recall correctly, about $500. They also syndicated the article to *The International Herald Tribune,* along with the photos, and with no further work from me I got a second cheque of $350 from the *Tribune.*

Incidentally, I have since sold work to *The Washington Post* – words and pictures!

ALLISTER MACPHERSON

Meeting fishing boats coming home is a holiday pastime that I always enjoy, but when I went to do this in Gourdon I spotted a girl crew member, and knew story number one had arrived.

I was soon to discover that Gourdon was the last place in the UK where line fishing was still practised. The fishermen's wives and daughters sat up through the nights baiting the lines, and with twelve hundred hooks per line, it was no light task.

Story number two had presented itself.

The pub at Gourdon harbour was like something out of history books and the landlord was a remarkable old character with a fund of amusing tales. Story number three.

I quite often produce feature material, travel pieces and single pics from Ireland. A silly postcard of mine, featuring a dog sitting on the back of a donkey, has been on sale throughout Ireland for the past few years.

This is just a small selection of photographers, all members of the Bureau of Freelance Photographers, who have made sales from their holiday pictures. And if they can do it, so can you, providing you listen to what they are saying. The important message each has to offer is to simply keep your eyes open and be aware of the tremendous opportunities that holiday photography can bring you.

It's time, then, to start approaching your annual two weeks in the sun in a completely different way. You've taken your last holiday snap. From now on, your days away will be full of freelance opportunities. Holidays will never be the same again!

ABOUT THE BFP

Founded in 1965, the Bureau of Freelance Photographers is today the major body for the freelance photographer. It has a worldwide membership, comprising not only full-time freelances, but also amateur and semi-professional photographers. Being primarily a service organisation, membership of the Bureau is open to anyone with an interest in freelance photography.

The major service offered to members is the *Market Newsletter*, a confidential monthly report on the state of the freelance market. A well-researched and highly authoritative publication, the *Newsletter* keeps freelances in touch with the market for freelance pictures. It gives full information on the type of pictures currently being sought by a wide range of publications and other outlets. It gives details of new magazines and their editorial requirements, and generally reports on what is happening in the publishing world and how this is likely to affect the freelance photographer.

The *Newsletter* is considered essential reading for the freelance and aspiring freelance photographer.

Other services provided to members for the modest annual subscription include:

● Annual Handbook. Full members receive the annual *Freelance Photographer's Market Handbook* as it is published.

● Advisory Service. Individual advice on all aspects of freelancing is available to members.

● Fee Recovery Service. The Bureau tries to protect its members' interests in every way it can. In particular, it is often able to assist individual members in recovering unpaid reproduction fees.

● Exclusive items and special offers. The Bureau regularly offers books and other items to members, usually at discount prices. It originated Editorial Submission Forms for use by members, and is also able to supply Model Release Forms. In addition, members are able to obtain discounts on various photographic goods and services, on production of a current membership card.

For further details and an application form, write to Bureau of Freelance Photographers, Focus House, 497 Green Lanes, London N13 4BP, or telephone 081-882 3315.

INDEX